PAINT ALONG WITH **JERRY YARNELL** • *VOLUME NINE*

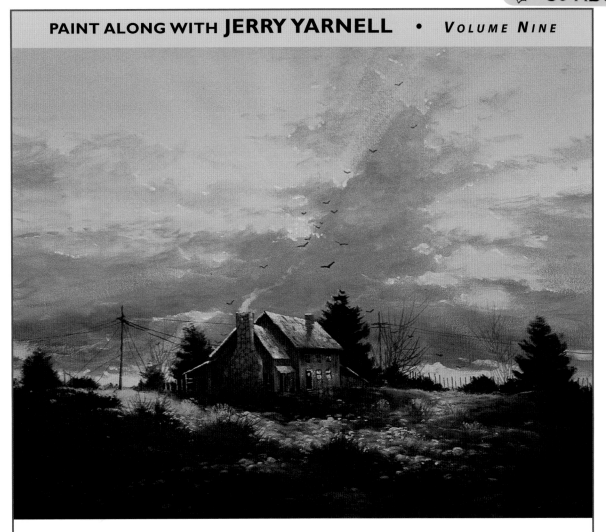

CREATING
Light

NORTH LIGHT BOOKS

CINCINNATI, OHIO
www.artistsnetwork.com

ABOUT THE AUTHOR Jerry Yarnell was born in Tulsa, Oklahoma, in 1953. A recipient of two scholarships from the Philbrook Art Center in Tulsa, Jerry has always had a great passion for nature and has made it a major thematic focus in his painting. He has been rewarded for his dedication with numerous awards, art shows and gallery exhibits across the country. His awards include the prestigious Easel Award from the Governor's Classic Western Art Show in Albuquerque, New Mexico; acceptance in the top 100 artists represented in the national Art for the Parks Competition; an exhibition of work in the Leigh Yawkey Woodson Art Museum "Birds in Art" Show; and participation in a premier showing of work by Oil Painters of America at the Prince Gallery in Chicago, Illinois.

Jerry has another unique talent that makes him stand out from the ordinary: he has an intense desire to share his painting ability with others. For years he has taught successful painting workshops and seminars for hundreds of people. Jerry's love for teaching also keeps him busy offering workshops and private lessons in his Yarnell Studio & School of Fine Art. Jerry is the author of eight books on painting instruction, and his unique style can be viewed on his popular PBS television series, *Jerry Yarnell School of Fine Art,* airing worldwide.

Paint Along With Jerry Yarnell, Volume 9: Creating Light. © 2004 by Jerry Yarnell. Manufactured in China. All rights reserved. No part of this book may be reproduced in any form or by any electronic or mechanical means, including information storage and retrieval systems, without permission in writing from the publisher, except by a reviewer, who may quote brief passages in a review. Published by North Light Books, an imprint of F+W Publications, Inc., 4700 E. Galbraith Road, Cincinnati, Ohio 45236. (800) 289-0963. First edition.

Other fine North Light Books are available from your local bookstore or art supply store or direct from the publisher.

09 08 07 06 05 5 4 3 2 1

Library of Congress Cataloging-in-Publication Data

Yarnell, Jerry.
 Paint Along with Jerry Yarnell.
 p. cm.
 Includes index.
 Contents: v. 9. Creating light
 ISBN 1-58180-441-5 (pbk. : alk. paper)
 1. Acrylic painting—Technique. 2. Landscape painting—Technique. I. Title

ND1535 .Y37 2002
751.4'26—dc21 00-033944
 CIP

Editor: Vanessa Lyman
Production coordinator: Mark Griffin
Production artist: Kendra Tidd
Photographer: Scott Yarnell

F+W PUBLICATIONS, INC.

DEDICATION

It was not difficult to know to whom to dedicate this book. I give God all the praise and glory for my success. He blessed me with the gift of painting and the ability to share this gift with people around the world. He has blessed me with a new life after a very close brush with death. I am here today and able to share all this with each of you because we have a kind, loving and gracious God. Thank you, God, for all you have done.

Also to my wonderful wife, Joan, who has sacrificed and patiently endured the hardships of an artist's life. I know she must love me or she would not still be with me. I love you, sweetheart, and thank you. Lastly, to my two sons, Justin and Joshua: you both are a true joy in my life.

ACKNOWLEDGMENTS

So many people deserve recognition. First I want to thank the thousands of students and viewers of my television show for their faithful support over the years. Their numerous requests for instructional materials are really what initiated the process of producing these books. I want to acknowledge my wonderful staff, Diane, Scott and my mother and father for their hard work and dedication. In addition, I want to recognize the North Light staff for their belief in my abilities.

FOR MORE INFORMATION

about the Yarnell Studio & School of Fine Art and to order books, instructional videos and painting supplies contact:

Yarnell Studio & School of Fine Art
P.O. Box 808
Skiatook, OK 74070

Phone: (877) 492-7635

Fax: (918) 396-2846

gallery@yarnellart.com

www.yarnellart.com

METRIC CONVERSION CHART

TO CONVERT	TO	MULTIPLY BY
Inches	Centimeters	2.54
Centimeters	Inches	0.4
Feet	Centimeters	30.5
Centimeters	Feet	0.03
Yards	Meters	0.9
Meters	Yards	1.1
Sq. Inches	Sq. Centimeters	6.45
Sq. Centimeters	Sq. Inches	0.16
Sq. Feet	Sq. Meters	0.09
Sq. Meters	Sq. Feet	10.8
Sq. Yards	Sq. Meters	0.8
Sq. Meters	Sq. Yards	1.2
Pounds	Kilograms	0.45
Kilograms	Pounds	2.2
Ounces	Grams	28.3
Grams	Ounces	0.035

Table of Contents

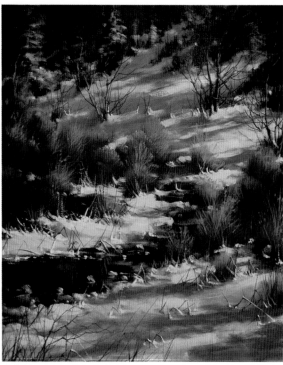

Frozen Shadows

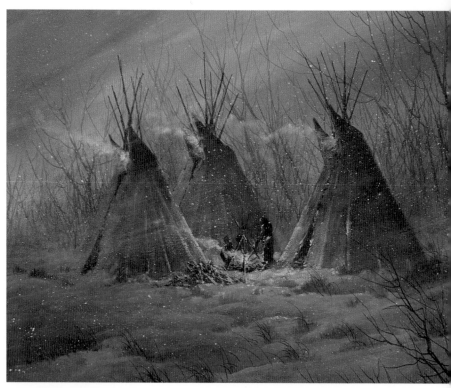

Campfire

Late Summer Glow

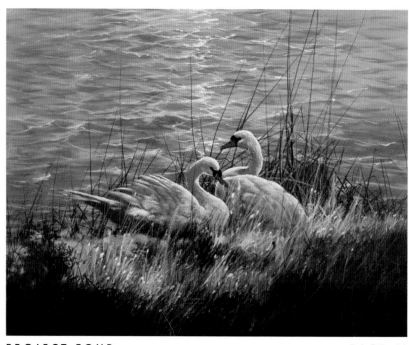

Evening Swans' Refuge

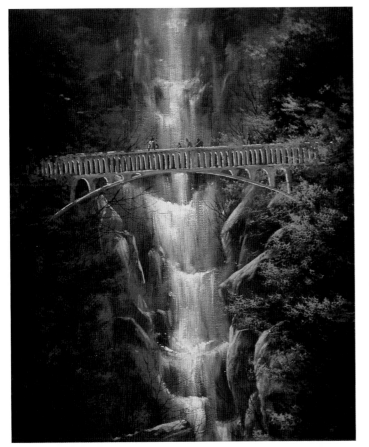

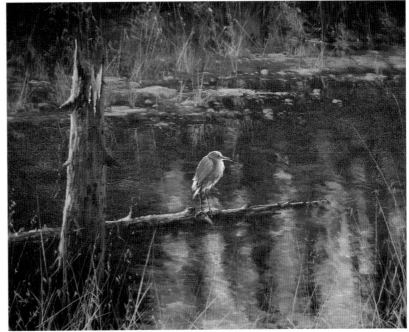

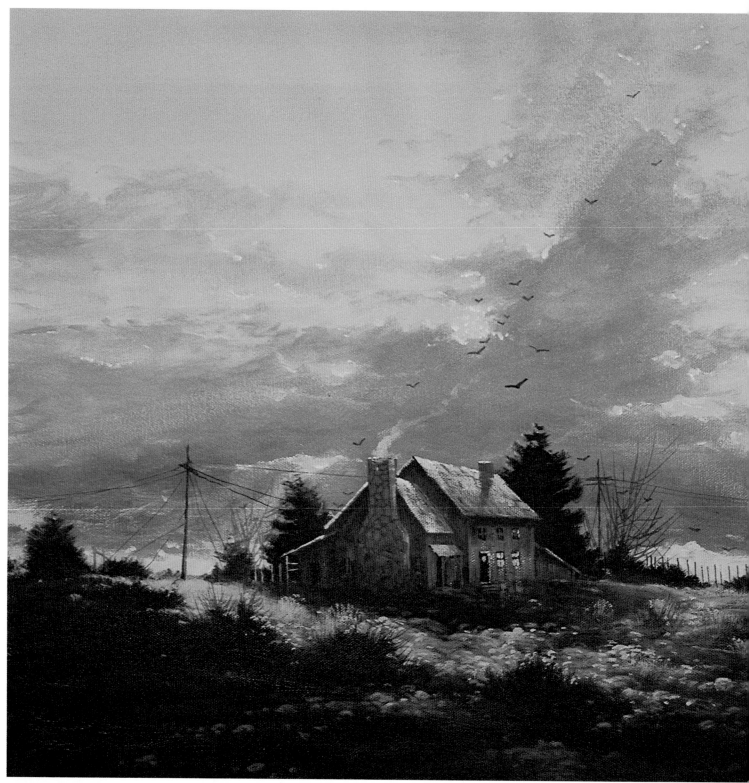

Late Summer Glow
16" × 20" (41cm × 51cm)

Introduction

Just exactly what is this thing called light? To an artist, quite simply, it's everything. It doesn't matter if you're a sculptor or a painter or even a dancer; anything that requires a three-dimensional interpretation can work only if light is present to define form and create shadow. In this book, we'll study several different aspects of light and attempt to unravel some of the mysteries surrounding this important and often misunderstood component of art. We'll learn about different types of light, including direct light, indirect light, reflected light, soft light, harsh light, sunlight and moonlight. We'll notice that in addition to warm light and cool light, there are many different colors of light. We'll see how early morning, afternoon and late evening light produce different shadows that affect the composition of a painting. Finally, we'll see that light is directly responsible for different moods that you can achieve in your paintings. Before we're through, you'll realize that without light, the world of art would not exist.

Terms & Techniques

Before beginning the step-by-step instructions on the following pages, you may want to refresh your memory by reviewing these terms and techniques.

COLOR COMPLEMENTS

Complementary colors always appear opposite each other on the color wheel. Use complements to create color balance in your paintings. It takes practice to understand how to use complements, but a good rule of thumb is to use the complement or a form of the complement of the predominant color in your painting to highlight, accent or gray that color.

For example, if your painting has a lot of green, use its complement, red—or a form of red such as orange or red-orange—for highlights. If you have a lot of blue in your painting, use blue's complement, orange—or a form of orange such as yellow-orange or red-orange. The complement of yellow is purple or a form of purple. Keep a color wheel handy until you have memorized the color complements.

DABBING

Use the dabbing technique to create leaves, ground cover, flowers, etc. Take a bristle brush and dab it on your table or palette to spread out the ends of the bristles like a fan (see above example). Then load the brush with the appropriate color and gently dab on that color to create the desired effect.

DOUBLE LOAD OR TRIPLE LOAD

To double or triple load a brush put two or more colors on different parts of your brush. Mix these colors on the canvas instead of your

To prepare your bristle brush for dabbing, spread out the ends of the bristles like a fan.

palette. Double or triple load your brush for wet-into-wet techniques.

DRYBRUSH

To drybrush, load your brush with very little paint and lightly skim the surface of the canvas with a very light touch to add, blend or soften a color.

EYE FLOW

Create good eye flow to guide the viewer's eye through the painting with the arrangement of objects on your canvas or the use of negative space around or within an object. The eye must move smoothly, or flow, through your painting and around objects. The viewer's eyes shouldn't bounce or jump from place

to place. Once you understand the basic components of composition—design, negative space, "eye stoppers," overlap, etc.—your paintings will naturally achieve good eye flow.

FEATHERING

Use feathering to blend, to create soft edges, to highlight and to glaze. Use a very light touch, barely skimming the surface of the canvas with your brush.

GESSO

Gesso is a white paint used for sealing canvas before painting on it. Because of its creamy consistency and because it blends so easily, I often

This sketch uses poor negative space. The limbs don't overlap each other, but are evenly spaced so there are few pockets of interesting space.

This sketch uses negative space well. The limbs overlap and include interesting pockets of space.

use gesso instead of white paint. When I use the word *gesso* in my step-by-step instructions, I am referring to the color white. Use gesso or whatever white pigment you prefer.

GLAZE (WASH)

A glaze or a wash is a thin layer of paint applied over a dry area to create mist, fog, haze or sunrays, or to soften an area that is too bright. Dilute a small amount of color with water and apply it to the appropriate area. You can apply the glaze in layers, but each layer must be dry before applying the next.

HIGHLIGHTING OR ACCENTING

Highlighting is one of the final stages of your painting. Use pure color or brighter values to give your painting its final glow. Carefully apply highlights on the sunlit edges of the most prominent objects in your paintings.

MIXING

If you plan to use a mixture often, premix a good amount of that color to have handy. I usually mix colors with my brush, but sometimes a palette knife works better. Be your own judge.

I also sometimes mix colors on my canvas. For instance, when I am underpainting grass, I may put two or three colors on the canvas and scumble them together to create a mottled background of different colors. This method also works well for skies.

When working with acrylics, always mix your paint to a creamy consistency that will blend easily.

NEGATIVE SPACE

Negative space surrounds an object to define its form and create good eye flow (see above example).

SCRUBBING

Scrubbing is similar to scumbling (below), but the strokes should be more uniform and in horizontal or vertical patterns. Use a dry-brush or wet-into-wet technique with this procedure. I often use it to underpaint or block in an area.

SCUMBLING

To scumble, use a series of unorganized, overlapping strokes in different directions to create effects such as clumps of foliage, clouds, hair, grass, etc. The direction of the stroke is not important for this technique.

UNDERPAINTING AND BLOCKING IN

The first step in all paintings is to block in or underpaint the dark values. You'll apply lighter values of each color to define each object later.

VALUE

Value is the relative lightness or darkness of a color. To achieve depth or distance, use lighter values in the background and darker values closer to the foreground. Lighten a color by adding white. Make a value darker by adding black, brown or the color's complement.

WET-ON-DRY

I use the wet-on-dry technique most often in acrylic painting. After the background color is dry, apply the top-coat by drybrushing, scumbling or glazing.

WET-INTO-WET

I use a large hake brush (pronounced *ha-KAY*) to blend large areas, such as skies and water, with the wet-into-wet technique. Blend the colors together while the first application of paint is still wet.

Make the value of a color lighter by adding white.

Getting Started

Acrylic Paint

The most common criticism of acrylics is that they dry too fast. Acrylics do dry very quickly because of evaporation. To solve this problem, I use a wet palette system (see pages 13-15). I also use specific dry-brush blending techniques to make blending easy. With a little practice you can overcome any of the drying problems acrylics pose.

Speaking as a professional artist, I have found that acrylics are ideally suited for exhibiting and shipping. You actually can frame and ship an acrylic painting thirty minutes after you finish it. You can apply varnish over an acrylic painting, but you don't have to because acrylic paint is self-sealing. Acrylics are also versatile because you can apply thick or creamy paint to resemble oil paint or paint thinned with water for watercolor techniques. Acrylics are nontoxic with little odor, and few people have allergic reactions to them.

USING A LIMITED PALETTE

I work from a limited palette. Whether for professional or instructional pieces, a limited palette of the proper colors is the most effective painting tool. It teaches you to mix a wide range of shades and values of color, which every artist must be able to do. Second, a limited palette eliminates the need to purchase dozens of different colors.

With a basic understanding of the color wheel, the complementary color system and values, you can mix thousands of colors for every type of painting from a limited palette.

For example, mix Thalo Yellow-Green, Alizarin Crimson and a touch of Titanium White (gesso) to create a beautiful basic flesh tone. Add a few other colors to the mix to create earth tones for landscape paintings. Make black by mixing Ultramarine Blue with equal amounts of Dioxazine Purple and Burnt Sienna or Burnt Umber. The list goes on and on, and you'll see that the sky isn't even the limit.

Most paint companies make three grades of paints: economy, student and professional. Professional grades are more expensive but much more effective. Just buy what you can afford and have fun. Check your local art supply store first. If you can't find a particular item, I carry a complete line of professional- and student-grade paints and brushes (see page 3).

see page 3

MATERIALS LIST

Palette

white gesso
Grumbacher, Liquitex or Winsor & Newton paints (color names may vary):

Alizarin Crimson

Burnt Sienna

Burnt Umber

Cadmium Orange

Cadmium Red Light

Cadmium Yellow Light

Dioxazine Purple

Hooker's Green

Phthalo (Thalo) Yellow-Green

Titanium White

Ultramarine Blue

Brushes

no. 4 flat sable brush

no. 4 round sable brush

no. 4 script liner brush

no. 4 flat bristle brush

no. 6 flat bristle brush

no. 10 flat bristle brush

2-inch (51mm) hake brush

Miscellaneous Items

16" × 20" (41cm × 51cm) stretched canvas

no. 2 soft vine charcoal

palette knife

paper towels

pastel pencil, Conté pencil or light-colored chalk

single-edge razor

Sta-Wet palette

spray bottle

toothbrush

Brushes

I use a limited number of brushes for the same reasons as the limited palette—versatility and economy.

2-INCH (51MM) HAKE BRUSH

Use a 2-inch (51 mm) hake brush for blending, glazing and painting large areas, such as skies and bodies of water, with a wet-into-wet technique.

NO. 10 FLAT BRISTLE BRUSH

Underpaint large areas—mountains, rocks, ground or grass—and dab on tree leaves and other foliage with a no. 10 flat bristle brush. It also works great for scumbling and scrubbing techniques. The stiff bristles are durable so you can treat them fairly roughly.

NO. 6 FLAT BRISTLE BRUSH

Use a no. 6 flat bristle brush, a cousin of the no. 10 flat bristle brush, for many of the same techniques and procedures. The no. 6 flat bristle brush is more versatile than the no. 10 because you can use it for smaller areas, intermediate details and highlights. You'll use the no. 6 and no. 10 flat bristle brushes most often.

NO. 4 FLAT SABLE BRUSH

Use sable brushes for more refined blending, details and highlights, such as final details, painting people and adding details to birds and other animals. Treat these brushes with extra care because they are more fragile and more expensive than bristle brushes.

NO. 4 ROUND SABLE BRUSH

Use a no. 4 round sable brush, like the no. 4 flat sable, for details and highlights. The sharp point of the round sable allows more control in areas where a flat brush will not work or is too wide. This is a great brush for finishing a painting.

NO. 4 SCRIPT LINER BRUSH

The no. 4 script liner brush is my favorite. Use it for very fine details and narrow line work, such as tree limbs, wire, weeds and especially your signature, that you can't accomplish with any other brush. Roll the brush in an ink-like mixture of pigment until the bristles form a fine point.

BRUSH-CLEANING TIPS

As soon as you finish your painting, use quality brush soap and warm water to clean your brushes thoroughly before the paint dries. Lay your brushes flat to dry. Paint is difficult to get out if you allow it to dry. If this does happen, use denatured alcohol to soften the dried paint. Soak the brush in the alcohol for about thirty minutes and then wash it with soap and water.

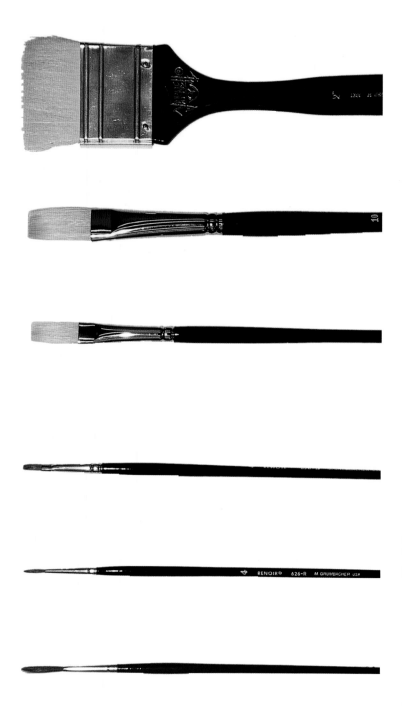

You can make any subject with this basic set of brushes. With this basic set of brushes, you can paint any subject.

Palettes

Several palettes on the market are designed to keep paints wet. I use two Sta-Wet Palettes made by Masterson. Acrylics dry because of evaporation, so keeping the paints wet is critical. The first palette is a 12" × 16" (30cm × 41cm) plastic palette-saver box with an airtight lid (see page 14). Saturate the sponge that comes with the palette with water and lay it in the bottom of the box. Then soak the special palette paper and lay it over the sponge. Place your paints around the edges and you are ready to go. Use a spray bottle to mist your paints occasionally so they will stay wet all day long. When you are finished painting, attach the lid and your paint will stay wet for days.

My favorite palette is the same palette with a few alterations (see page 15). Instead of the sponge and special paper, I place a piece of double-strength glass in the bottom of the palette. I fold paper towels into quarters to make long strips, saturate them with water and lay them on the outer edges of the glass. I then place my paints on the paper towels. They stay wet for days. I occasionally mist them to keep the towels wet.

If you leave your paints in a sealed palette for several days without opening it, certain colors, such as Hooker's Green and Burnt Umber, will mildew. Just replace the color or add a few drops of chlorine bleach to the water in the palette to help prevent mildew.

To clean the glass palette, allow it to sit in water for about thirty seconds or spray the glass with your spray bottle. Scrape off the old paint with a single-edge razor blade.

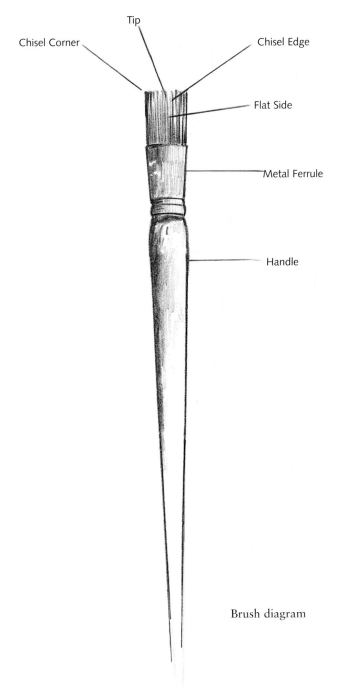

Tip

Chisel Corner

Chisel Edge

Flat Side

Metal Ferrule

Handle

Brush diagram

Working With A Palette

1 The Sta-Wet 12" × 16" (30cm × 41cm) plastic palette-saver box comes with a large sponge that you saturate with water.

2 Lay the wet sponge inside the palette box, soak the special palette paper and lay it over the sponge. Place your paints around the edges. Don't forget to mist them to keep them wet.

3 When closing the palette-saver box, make sure the airtight lid is on securely. When the palette is properly sealed, your paints will stay wet for days.

1 Instead of using the sponge and palette paper, you can use a piece of double-strength glass in the bottom of the palette. Fold paper towels in long strips and saturate them with water.

2 Lay the saturated paper towels around the outer edges of the glass.

3 Place your paints on the paper towel strips.

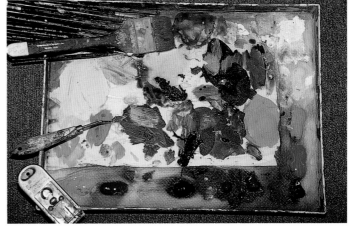

4 Use the center of the glass for mixing paints. Occasionally spray a mist over the paper towels to keep them wet.

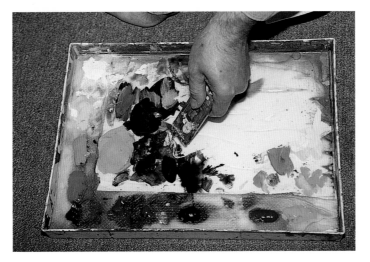

5 To clean the palette, allow it to sit for thirty seconds in water or spray the glass with a spray bottle. Scrape off the old paint with a single-edge razor blade.

Miscellaneous Supplies

CANVAS

Canvas boards work for practicing strokes, and canvas paper pads work for studies or testing paints and brush techniques. The best surface for painting, though, is a primed, prestretched cotton canvas with a medium texture, which you can find at most art stores. As your skills advance, you may want to learn to stretch your own canvas, but 16" × 20" (41cm × 51cm) prestretched cotton canvases are all you'll need for the paintings in this book.

EASEL

I prefer a sturdy, standing easel. My favorite is the Stanrite ST500 aluminum easel. It is lightweight, sturdy and easy to fold up to take on location or to workshops.

LIGHTING

Of course, the best light is natural north light, but most of us don't have this light in our work areas. The next best lighting option is to hang 4' (1.2m) or 8' (2.4m) fluorescent lights directly over your easel. Place one cool bulb and one warm bulb in the fixture to best simulate natural light.

Studio lights

16" × 20" (41cm × 51cm) stretched canvas

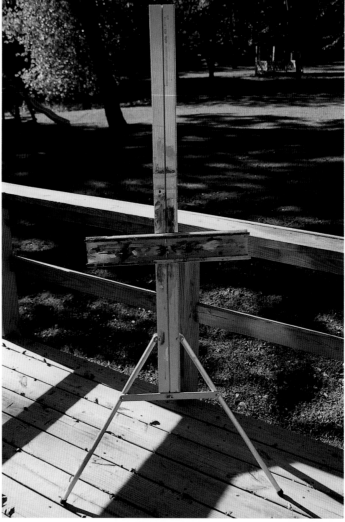

Stanrite aluminum studio easel

SPRAY BOTTLE

I use a spray bottle with a fine mist to lightly wet my paints and brushes throughout the painting process. I recommend a spray bottle from a beauty supply store. It's important to keep one handy.

PALETTE KNIFE

I use my palette knife more for mixing than for painting. A trowel-shaped knife is more comfortable and easier to use than a flat knife.

SOFT VINE CHARCOAL

I use no. 2 soft vine charcoal for most of my sketching. It's easy to work with, shows up well and is easy to remove with a damp paper towel.

Spray bottle

Soft vine charcoal

Palette knives

The Characteristics of Light

Before we get into the instructional paintings, let's take a look at some of the different characteristics of light. Let's first remember that light is the single most important element of all of the art forms. Composition, design, perspective, color, value—all of those are useless without light. Light's main function is to define form, but it also has great aesthetic qualities. It helps us better recognize color and creates both mood and atmosphere. It helps us establish values. Its different applications— direct light, indirect light, warm or cool light or glowing light— make it useful in designing a painting. There are many possibilities. We're just going to look at a few of the most important applications, as they pertain to most of us.

No Light, No Form

The best place to start is with understanding how light affects an object. For example, you can see this simple line drawing is a circle, but that's it. It's round, but has no three-dimensional form.

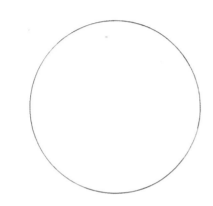

Light Defines Form

Now, take a look at this illustration. With the presence of light, the once simple line drawing of a circle now becomes a three-dimensional sphere. With light, we now have a form that has three values: dark, middle, light, which in turn causes the object to appear three-dimensional.

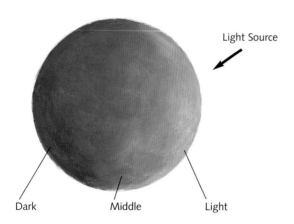

Light Source

Dark Middle Light

Light Causes Shadows

Light causes simple, one-dimensional objects to look three-dimensional, but light is also responsible for creating shadows. There are two types of shadows that give an object its three-dimensional form. The first is a form shadow, which appears on an object in an area untouched by direct light. The other type is a cast shadow. A cast shadow appears when light hits an object, and that object casts a shadow on another object.

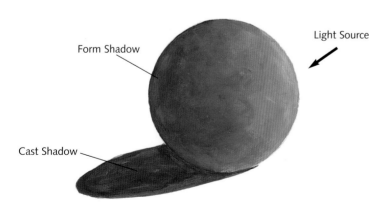

Form Shadow

Light Source

Cast Shadow

Direct Light

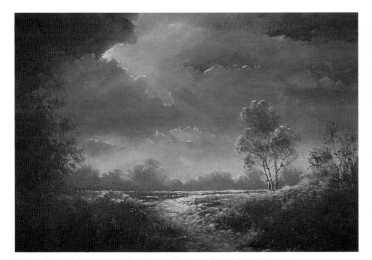

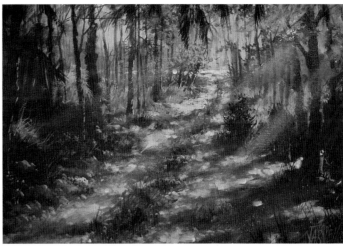

Direct Lighting With a Single Shaft of Light

The lighting in this painting is the most common form, called direct light, when an object or area is illuminated by light from a single source. This is usually a ray of light, like the beam of a flashlight. Here, the light comes from the sun, which is partially covered by a cloud. This shaft of light illuminates a particular area in the painting, so the highlight is focused on an area instead of an object.

Heaven's Course
16" × 20" (41cm × 51cm)

A More Precise Illumination

The sun, located somewhere above the canopy of leaves, generates sunrays. The leaves, like the clouds in the other paintings, block most of the light. The only light that can penetrate the leaves is the small shafts that shine on individual areas of the road. This adds drama to the setting.

Dancing Shadows
16" × 20" (41cm × 51cm)

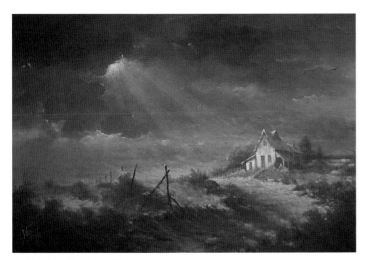

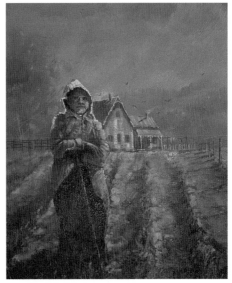

A Wider Illumination

This lighting situation is similar to the one above. The main difference is that this shaft of light is designed to illuminate not only a spot or small area, but also the house and objects around it.

Piercing Through the Storm
16" × 20" (41cm × 51cm)

Complete Illumination

This painting uses direct light, but unlike the other paintings, this light isn't blocked. Instead of casting shafts of light, the light source comes from a certain direction and illuminates the entire painting. This type of direct light is more evenly distributed, as though it were a midday or late afternoon setting. The shadows and highlights are softer in tone and value. This is one of the more common lighting situations.

Grandma's Garden
20" × 16" (51cm × 41cm)

Backlighting and Silver Linings

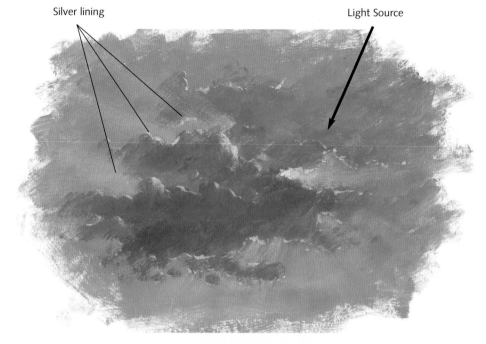

Silver lining

Light Source

Silver Lining

You might have heard the term *silver lining*, which is an effect created by backlighting. Backlighting occurs when the light source is directly behind an object, creating a silhouette. The thin accent highlights that illuminate the outer edge of the silhouette are called the silver lining. In painting, this effect is most often used in late evening or early morning situations. A silver lining can also be created for a midday setting if the sun is being blocked by a cloud formation, in which case, a silver lining will outline the cloud's edge. This is probably the most common use of the silver lining. It's nothing more than backlighting, but it can create great drama.

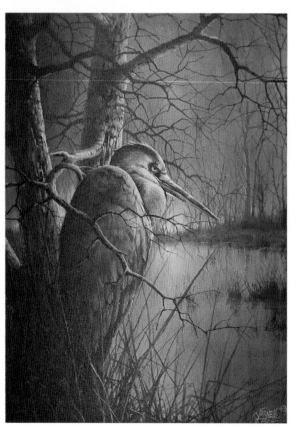

Silver Lining and Detail

In this painting, the light source is the late evening sunset. The sun is directly in the center of the painting behind all of the main objects, which creates silhouettes accented by a silver lining. Backlit objects frequently don't have much three-dimensional form, as is the case in this painting. The great blue heron is more detailed because it is closer to the viewer, but notice the trees and bushes are almost strictly silhouettes, with slight silver lining on their edges.

Silent Fisherman
26" × 20" (41cm × 51cm)

Reflected Highlights

Light Source | No reflected highlight: stump looks flat on shadowed side

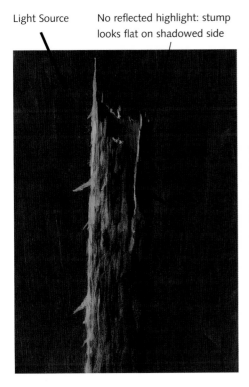

Light Source | Reflected highlight: stump looks three dimensional

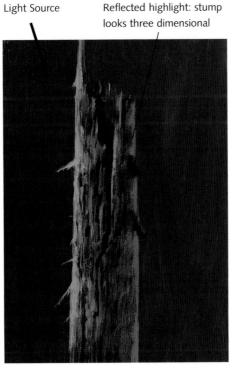

Reflected Highlights

Another type of light often overlooked artists (especially beginning artists) is reflected light. Reflected light is the soft, usually bluish or purplish gray highlight located on the shadowed side of an object that helps establish its roundness or three-dimensional form. This is not an accent or direct light, but rather an indirect light. In this example, the shadowed side is nothing more than a dark value. It has less round-ness and three-dimensional form and frankly isn't as interesting. When the reflected highlight is added, the overall stump appears much softer, taking on a more rounded three-dimensional appear-ance. When you apply this highlight, grad-ually fade the highlight color across the shadowed area until it disappears. It is important that you don't leave a hard edge.

Reflected Highlights on Unusual Shapes

This is another example with a differently shaped object. In the illustration without the reflected highlight, the rock doesn't have much roundness or form. It looks more like a single solid lump than it really is. Once highlights are added to areas that would catch and reflect this light, the rock becomes three-dimensional and more interesting.

Light source | No reflected highlights

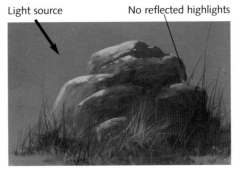

Light source | Reflected highlights

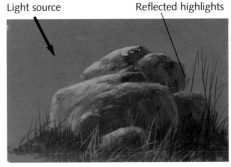

Color Formulas for Reflected Highlights

There are a couple of different formulas for creating a reflected highlight color. Keep in mind this is only the basic formu-la. You can adjust it to fit your painting's color scheme, making it warmer or cooler, for instance.

Titanium White + Dioxazine Purple + Ultramarine Blue = reflected highlight/ base color (cool tone)

Base color (cool tone) + Alizarin Crimson = reflected highlight (warm tone)

Glowing Light

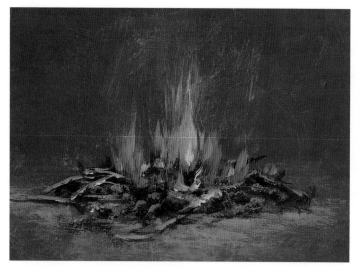

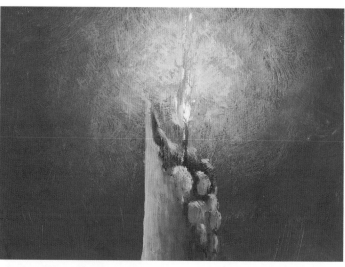

The Warm Glow of a Campfire

Another type of light that we often work with is glowing light from an object like a candle, a light bulb or even a campfire. This particular type of light does not illuminate with rays or shafts of light, like the sun. A glowing light usually gives off a soft, warm radiance that illuminates the objects immediately around it. In this example, a rich, warm glow spreads out and illuminates the objects that surround the campfire.

The Cooler Glow of a Candle

This is another example of a soft glowing light, which in this case comes from a candle. The soft, warm and hazy glow surrounds the wick and then radiates out to illuminate other objects that are relatively close to the candle. Almost all glowing light has a warm tone, ranging from yellowish all the way to red-hot. With this candle, I used a yellowish orange glow.

Color Formulas for Glowing Light

These are just a few swatches of color mixtures that are most often used in creating a glowing light.

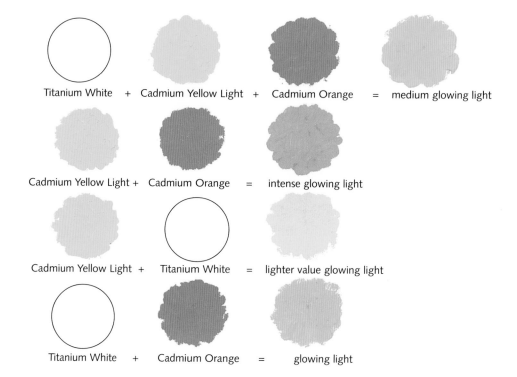

Titanium White + Cadmium Yellow Light + Cadmium Orange = medium glowing light

Cadmium Yellow Light + Cadmium Orange = intense glowing light

Cadmium Yellow Light + Titanium White = lighter value glowing light

Titanium White + Cadmium Orange = glowing light

Warm and Cool Light

In these next two examples, we are going to look at how the light's temperature creates an evening or morning atmosphere. Remember, these are only general rules and are subject to adjustment or change depending on the result you are after. Normally, I use cooler tones of light and shadow to suggest an early morning atmosphere and warmer tones of light and shadow to suggest a late evening atmosphere.

Cool Tones

Cool tones usually help create an early morning atmosphere, as is the case with this painting. Notice the cool grayish green background. The yellowish highlight on the grass, the dark greens of the foreground trees, along with deep shadows and intense highlights, are indications of an early morning. This lighting situation is caused by the sunlight being fairly low to the horizon and diffused through the canopy of leaves.

Spring Road
20" × 16" (51cm × 41cm)

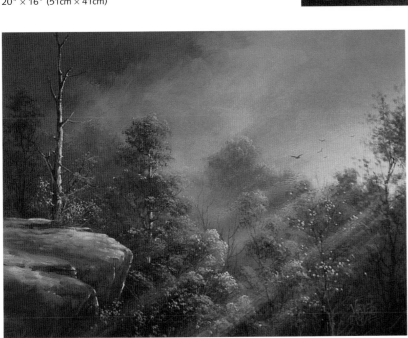

Warm Tones

Unlike *Spring Road* (above), where I worked with cool tones and highlights to suggest early morning, in *Autumn Wonders* I worked mostly with warm tones and highlights to suggest late evening. Another interesting aspect of this painting is the shafts of light coming through the pockets or openings in the clumps of leaves. This is another application of light that adds great drama to either a late evening or early morning painting.

Autumn Wonders
16" × 20" (41cm × 51cm)

Miscellaneous Effects of Light

In these next few examples, we are going to look at several paintings that I have done that show some of the practical applications and different types of light that we have just been discussing.

The First Application of White Light

This is a small section of a painting called *Early Snow on the Narrow Gauge*. I wanted to show this section because the beam of light radiating from the locomotive's headlamp is the sole source of light with a very narrow scope of illumination, much like a sunray. The color of this of light is a yellowish white. Some artists refer to this type of light as *white light* because it is a very clean light.

Early Snow on the Narrow Gauge (detail)
16" × 20" (41cm × 51cm)

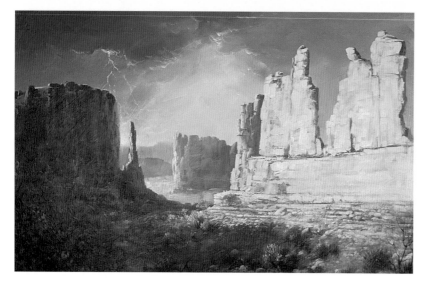

The Second Application of White Light

The most intense lighting here is the whitish light reflected on the large rock formations on the right side of the painting. This is the second application of white light in which the light illuminates a solid object; the first application was the beam of light. Also notice that the white light works well for the streaks of lightning and silver lining on the clouds. The true drama in this composition comes from the light source, which is low on the horizon behind the viewer. The bright light battles the dark storm clouds, causing strong light and shadow. This painting really has it all.

Guardians of the Valley
16" × 20" (41cm × 51cm)

Color Formula for White Light

This color swatch shows you the formula for creating white light. The main mixture is three parts Titanium White with one part Cadmium Yellow Light. To warm it up, add touches of Cadmium Orange or Cadmium Red Light.

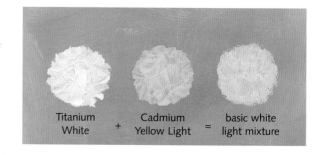

| Titanium White | + | Cadmium Yellow Light | = | basic white light mixture |

Midday Sunlight

The sun, which is the only light source in this case, is almost directly overhead. A light source like this usually suggests midday or early afternoon. The light isn't strong, direct light; because it's more evenly distributed throughout the landscape, it seems softer and less intense. You still have highlights and shadows; they're simply less intense in value. For beginners, this is probably the most common approach to lighting a landscape.

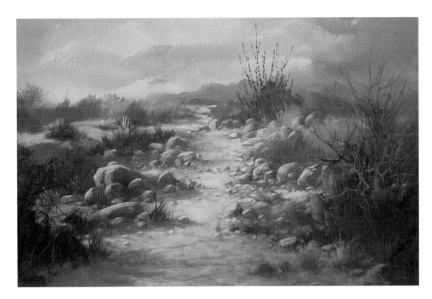

Wilderness Walk
16" × 20" (41cm × 51cm)

A Moonlit Night

There's no visible horizon line in this painting, which is interesting. Also, because of the location of the light and shadows and the coolness of the tones, it appears to be evening. The strong, deep shadows and strong, intense highlight indicate that this could be night with the moon as the light source.

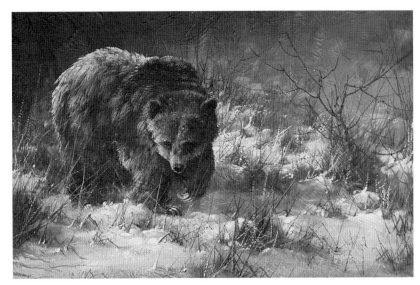

On the Prowl
16" × 20" (41cm × 51cm)

A Glowing Sunset

In this painting, I painted a warm glowing sunset that provided the opportunity to work with backlighting. What makes this lighting situation work is the sun positioned so low on the horizon, where I created a glowing light similar to that of a campfire or a light at the window. The rich yellow-orange tones of the light bounce off the dense, dark cloud formation, illuminating the edges of the cabin and raised areas of the snow.

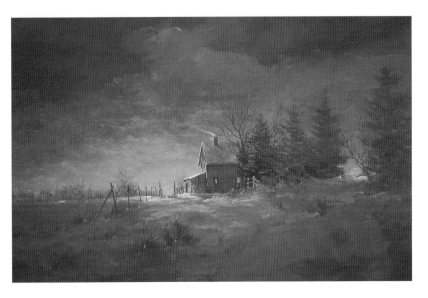

Evening's Final Glow
16" × 20" (41cm × 51cm)

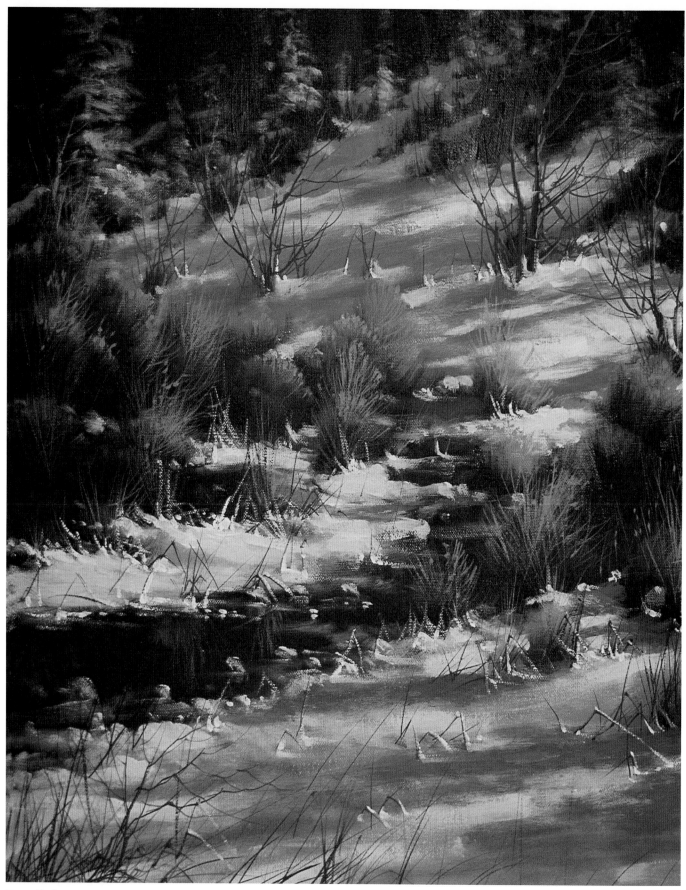

Frozen Shadows
20" × 16" (51cm × 41cm)

Frozen Shadows

In this painting, you can see how low, direct sunlight creates long, crisp shadows. The contrast of the dark bushes against the clean, bright snow creates a late evening atmosphere, just as I wanted. By painting long, vertical shadows that follow the ground's contour, I added another late evening element. Keep in mind that the lower the light, the longer the shadow. Another element of this painting that creates the effect of evening is the strong, bright colors. The warm orange sunlight on the bushes really makes them stand out against the cool shadows of the snow. All the accent highlights have strong, clean colors, from the whites to the golds to the oranges. By using contrasting colors and intensities, you can create the wonderful atmosphere of a cold, crisp evening that makes you want to shiver. I hope you enjoy this painting. Remember: the key is strong, bright, colorful light.

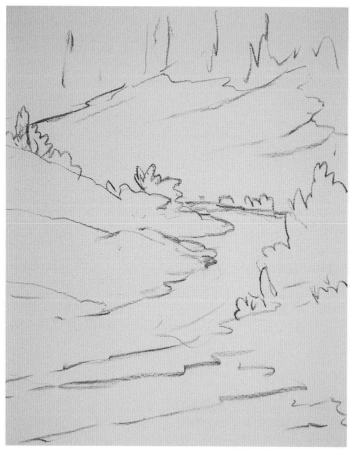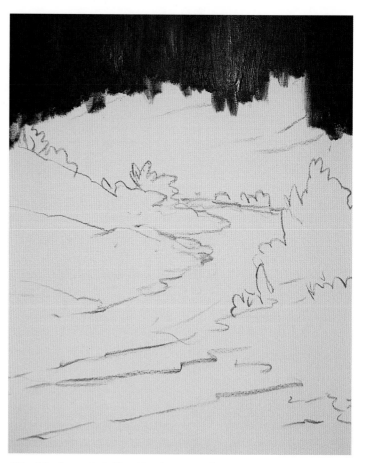

1 Basic Sketch

As you'd expect, you start the painting with a sketch. Use your soft vine charcoal to make a rough sketch. You want to catch the composition's basic layout and the lay of the landscape.

2 Underpaint the Background Trees

You'll need a variety of darker colors to suggest a dense forest, so we'll mix the colors on the canvas. Triple load your no. 10 bristle brush by dipping into three different colors: Hooker's Green, Burnt Sienna and just a dab of Dioxazine Purple. Now, apply this to the upper background area using loose vertical strokes. It's important to make this area opaque, so apply the paint fairly heavily and don't overblend. Reload the brush and repeat this step every few inches until the entire background is complete. It's okay to add a little water; just be careful not to add too much or the paint will become transparent.

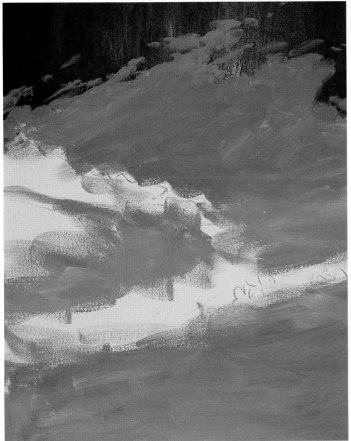

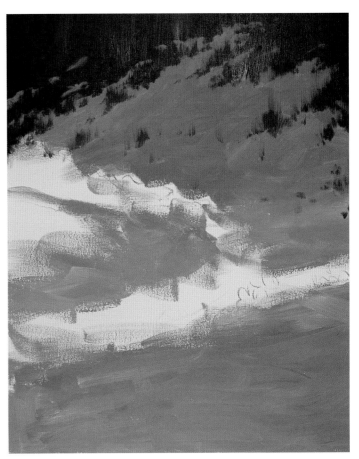

3 Underpaint the Snow

For this step, you need to mix a large pile of color. Mix about four parts Ultramarine Blue with one part Burnt Sienna and one part Dioxazine Purple, then add one part gesso. This should create a medium purplish gray. Don't be afraid to adjust the color or value by adding to or taking away from the mixture. When you have your desired color, take your no. 10 bristle brush and use large bold strokes to completely underpaint the snow areas. It's important to cover this entire area well, so apply the paint heavily enough to create an opaque coverage.

4 Underpaint the Background Grass Clumps

Create a mixture of about four parts Hooker's Green and one part Burnt Sienna, then add a small dab of Dioxazine Purple. The result should be a fairly dark olive green. Add a little water to make the mixture creamy, then load your no. 10 bristle brush with a small amount of the mixture, just on the ends of the bristles. Then use a careful but quick vertical stroke to create the suggestion of bushes; start at the bottom of each clump of brush, pulling upward. Arrange different sizes and shapes through the area, but don't overdo it.

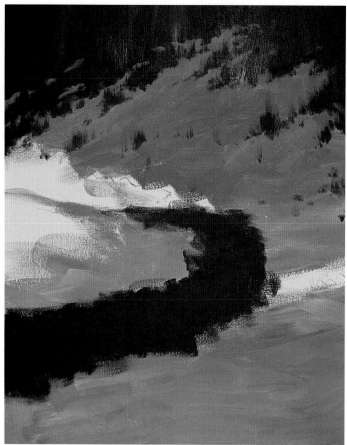

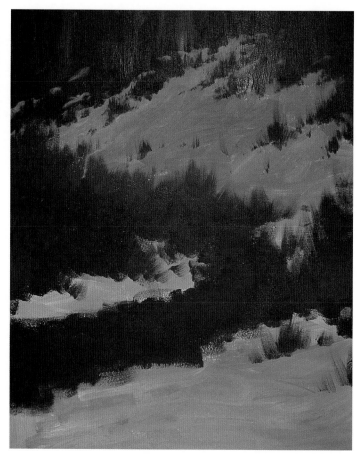

5 Underpaint the Water

Create a deep emerald green by mixing four parts Hooker's Green with one part Ultramarine Blue, one part Dioxazine Purple and a small touch of Burnt Sienna. Once you are satisfied with your mixture, take your no. 10 bristle brush and paint in the water. When you highlight the snow later, you'll overlap this water area, so it's a good idea to paint the water area larger than necessary.

6 Underpaint the Middle-Ground Bushes

The middle-ground bushes should have a deep, rich, warm tone to them, so create a mixture of four parts Burnt Sienna and one part Dioxazine Purple, then add just a small amount of gesso. Add a little water to make the mixture creamy, then take your no. 10 bristle brush and paint in a nice collection of bushes. Be sure to create a nice arrangement with good negative space around the clumps. You'll highlight them in a later step to create a wider variety of shapes and to give them more form. Remember, this is only the underpainting.

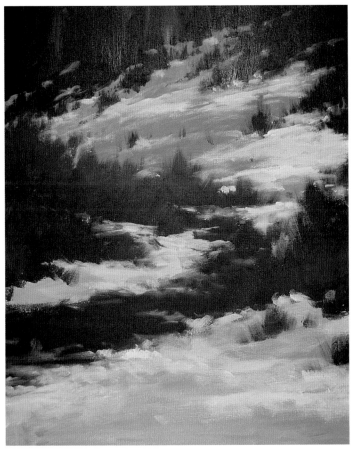

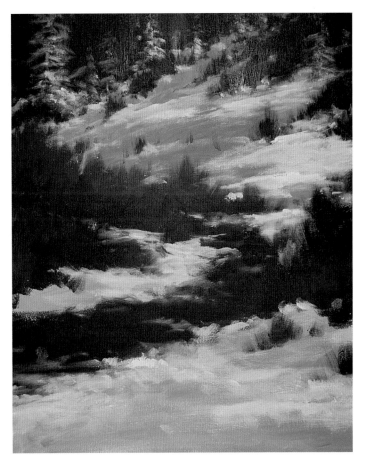

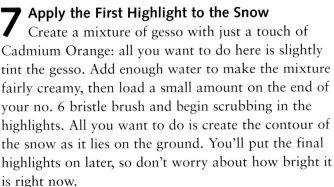

7 Apply the First Highlight to the Snow

Create a mixture of gesso with just a touch of Cadmium Orange: all you want to do here is slightly tint the gesso. Add enough water to make the mixture fairly creamy, then load a small amount on the end of your no. 6 bristle brush and begin scrubbing in the highlights. All you want to do is create the contour of the snow as it lies on the ground. You'll put the final highlights on later, so don't worry about how bright it is right now.

8 Highlight the Pine Trees

These pine trees are distant and don't need much detail, so highlight them carefully. The mixture for this highlight color is gesso with slight touches of Ultramarine Blue and Dioxazine Purple. Once again, all you want to do here is tint the gesso, although it's a little darker than the highlight color used in step 7. Scrub in the highlights with this mixture and your no. 6 bristle brush. The interesting thing about this step is that you highlight and create form at the same time. Be careful not to overhighlight, and remember to leave interesting pockets of negative space in, around and through the trees.

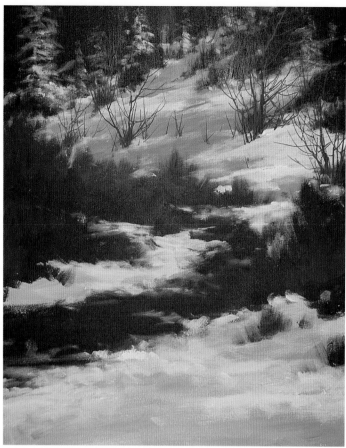

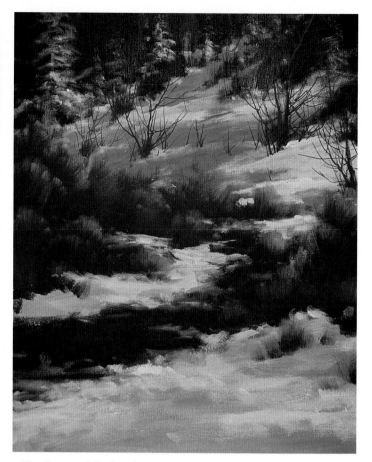

9 Paint the Dead Bushes

Now it is time to add some of the dead bushes. Create an inklike mixture of four parts Burnt Sienna, one part Ultramarine Blue, one part Dioxazine Purple and plenty of water. If you find the mixture to be too dark, don't hesitate to add a bit of gesso to lighten the value. Roll your no. 4 script liner brush around in the mixture until the bristles form a point. Paint a collection of dead bushes along the middle background area of the painting.

10 Highlight the Bushes

Create a mixture of Cadmium Orange with slight touches of Burnt Sienna and a slight touch of gesso. Load a small amount on the end of your no. 10 bristle brush. Start at the top of each bush, pulling downward with a quick, light dry-brush stroke. The key here is to keep the highlight mostly on the top of each bush. This highlight is also the key to creating the form of each bush throughout the dark underpainting. Keep in mind that you'll paint the final highlights in a later step.

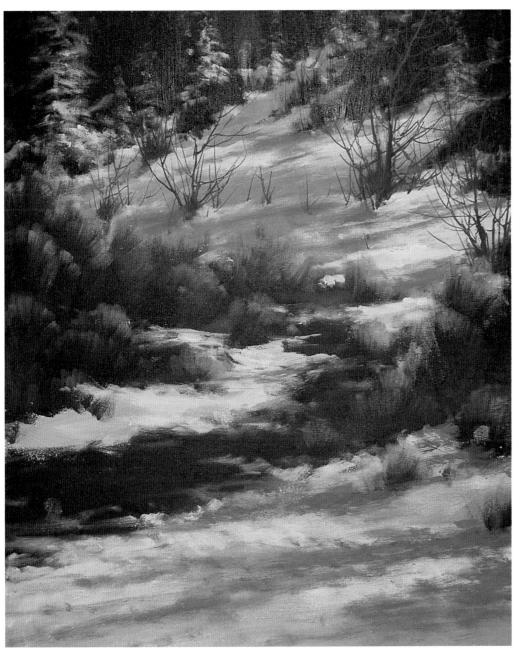

11 Add Shadows to the Snow

Create a rich, soft shadow color by mixing about four parts Ultramarine Blue with two parts gesso, one part Dioxazine Purple and a touch of Burnt Sienna. You may have to experiment with the amounts of each color to get just the right soft purplish gray tone. Scrub in shadows with your no. 6 brush, following the contour of the snow. Keep in mind that these shadows are the first element in creating the dramatic light of this painting, so it's important to scrub in long strips of this shadow color, leaving interesting pockets of the light areas of the snow showing through.

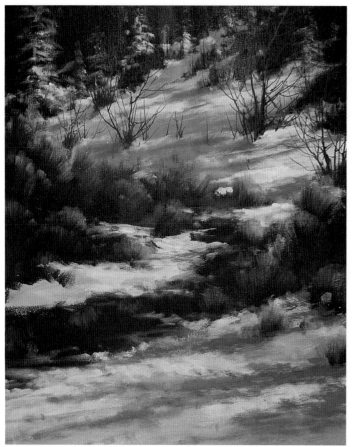

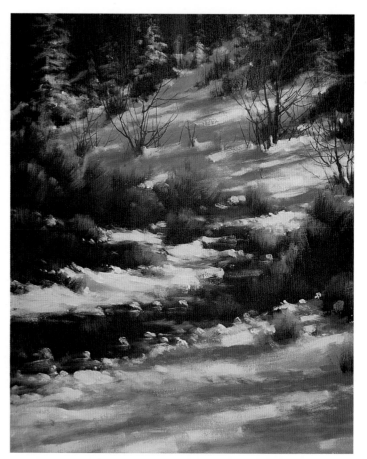

12 **Add the Water's Reflections**
This is a fairly simple step. First, create a mixture of two parts Burnt Sienna and one part Cadmium Orange, then take your no. 6 or no. 10 bristle brush and, using a downward dry-brush stroke, paint in a few reflections from the bushes. Keep in mind that the reflections aren't exact replicas of the bushes, but suggestions. The main purpose of these reflections is to break up the dark emerald green water with the burnt orange color. This works well to create color harmony, just as the dark water contrasting against the snow is what helps the painting to have strong light. Since the strong light is the painting's focus, don't overdo the reflections.

13 **Apply the Second Highlight to the Snow**
Re-create the snowy highlight mixture of gesso and a slight touch of Cadmium Orange from step 7. Load your no. 6 bristle brush heavily, then scrub in highlights on top of the existing areas of light snow. Apply the paint heavily using bold, broad strokes. The paint needs to be thick to make it opaque, which in turn makes the snow look bright. Be sure you soften the edges of each stroke into the shadowed areas.

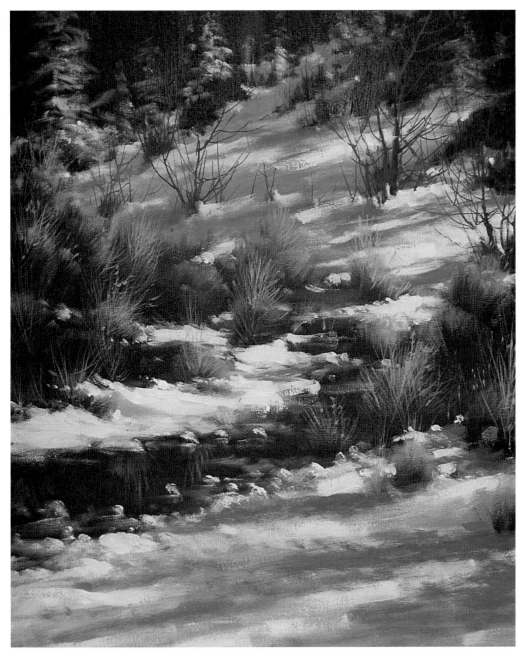

14 Highlight the Tips of the Bushes

For the taller grasses that grow out of the clumps, create a mixture of one part Cadmium Yellow Light, one part Cadmium Orange and a touch of gesso to opaque it. Add enough water to give it an inklike consistency. Load your no. 4 script liner brush by rolling it in the mixture until it forms a point. Paint in the brighter tall weeds, starting at the bottom and pulling upward. Add a few of these in the water to suggest reflections.

15 Add Foreground Grasses

In this step, you will add touches that make the painting appear more complete. Mix together four parts Burnt Sienna and one part Dioxazine Purple with a touch of Cadmium Orange to create a deep rust color. Once this is mixed, load your no. 6 bristle brush and add any clumps of bushes that would help complete the foreground. When you're satisfied with this, thin the mixture to an inklike consistency. Use your no. 4 script liner brush to paint in the foreground grasses and dead bushes in the lower-left corner. Notice how many of the grasses are bent over.

16 Create Snow Drifts

Mix together gesso and Cadmium Orange, just enough to tint the gesso. Heavily load either your no. 4 round or no. 4 flat sable (whichever works best for you) with the white mixture, then paint snow drifts up against the base of the bushes and grasses. Apply the paint heavily so the drifts will look bright. These drifts add a bright sunlit effect to the painting, almost like a sparkle.

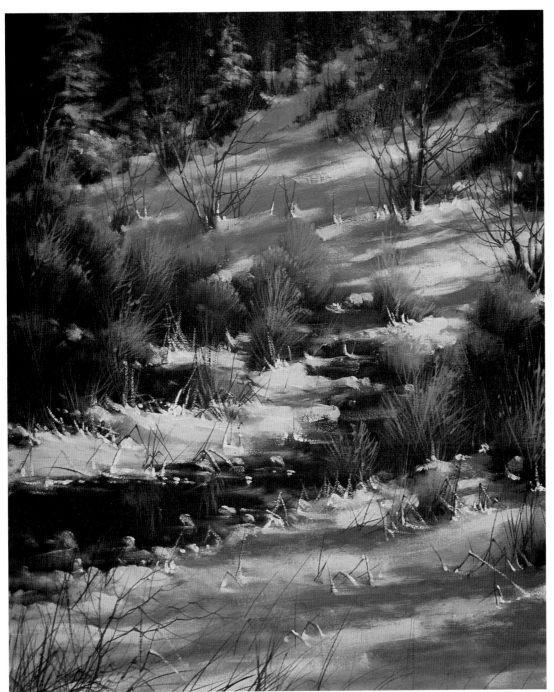

17 Add the Final Details and Highlights

This step is mostly about accenting with brighter, lighter colors to add to the sunlit, sparkling effect. Mix together Cadmium Orange and a touch of gesso. You'll do most of the detail work with your no. 4 script liner brush, so thin the mixture slightly. Paint in some light-colored grasses against the dark clumps of bushes. Continue using your script liner brush to highlight the dead trees in the middle background. This would be a good time to stand back and see if the painting needs additional accenting, either with this color or the white mixture from step 16. Have fun, but don't overhighlight!

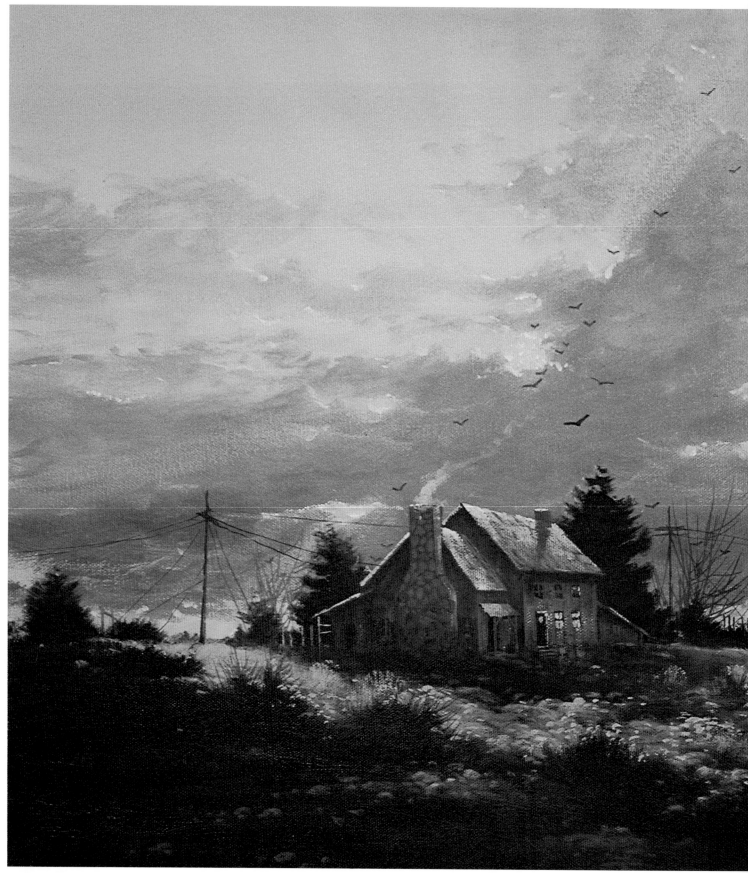

Late Summer Glow
16" × 20" (41cm × 51cm)

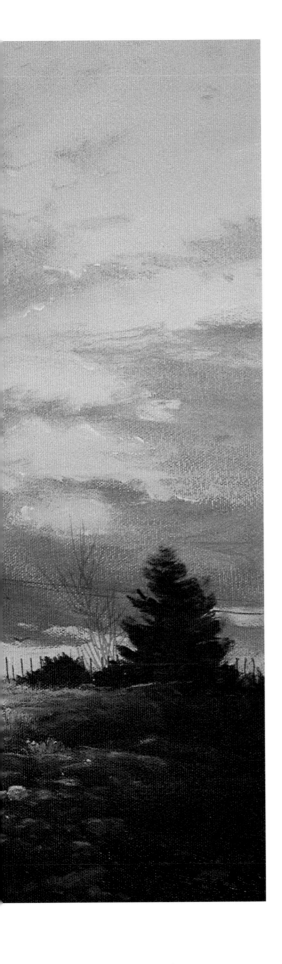

Late Summer Glow

In this painting, there are several different effects of light. The light source is obviously behind the center of interest so the painting is backlit. Generally speaking, backlighting causes most foreground objects to appear as silhouettes. As you can see in this painting, the cedar trees are only dark forms against the sky, just as the foreground grasses and bushes are only dark forms against the ground. The house has flat surfaces, so it will pick up enough light to reveal its three-dimensional form, but for the most part it will be in shadow. Another interesting element of a backlit painting is the presence of silver linings. In this case, the sun is directly behind a group of clouds, so you can see a very thin sliver of light that accents the outer edges of the clouds: the silver lining. This effect adds great drama to this late evening scene.

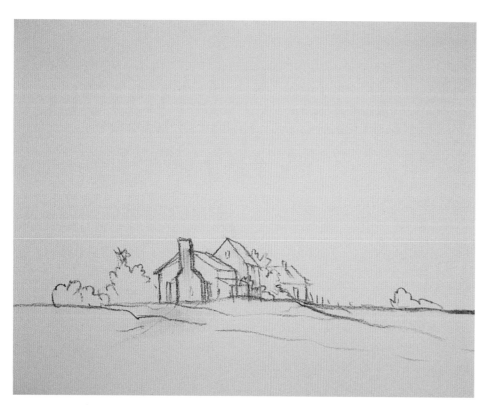

1 Basic Sketch

Start with your soft vine charcoal, roughly sketching in the basic components of the landscape. There's no need to draw in the details here.

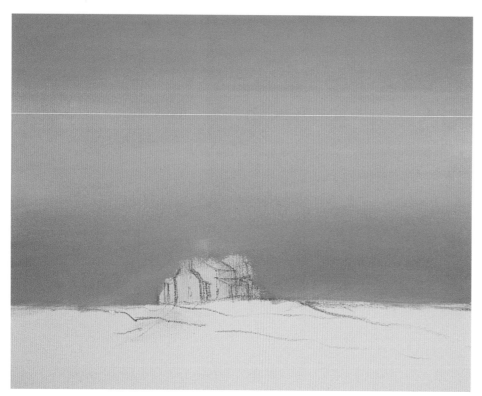

2 Block in the Sky

Lightly wet the background with your hake brush and then quickly apply an even coat of gesso over the entire sky. While this is still wet, double load your hake brush with Cadmium Yellow Light on one corner and Cadmium Orange on the other corner. Beginning at the horizon, blend these colors together using large X-strokes. Continue blending them all the way to the top until you have a nice golden yellow tone. While this is still wet, add a little Burnt Sienna to the top of the sky. Blend it downward using the same X-strokes until the Burnt Sienna gradually fades into the background.

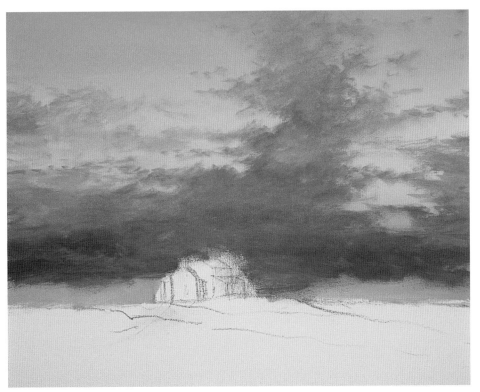

3 Underpaint the Sky

Be sure the sky is completely dry before continuing. Once it's dry, mix together the color for the clouds. To create the base color, mix four parts Burnt Sienna, one part gesso and a touch of Dioxazine Purple. You can adjust the value as needed: to lighten it, add more gesso; to darken it, add a touch more Burnt Sienna and Dioxazine Purple. Make the mixture creamy, then load a small amount on the end of your no. 10 bristle brush. Scrub in the clouds using the side of the brush. Keep the edges of the clouds soft and irregular and, of course, make sure you create unique shapes.

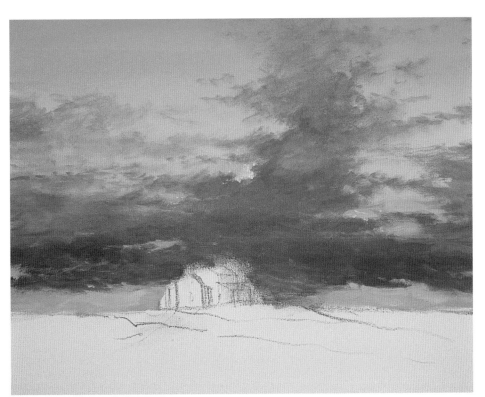

4 Add the Glow of Sunlight

To add the bright glow of sunlight, create a mixture of Cadmium Yellow with touches of Cadmium Orange and gesso. With your no. 4 flat sable brush, dab this bright color along the horizon and in some of the pockets within the cloud formations. Once you have brightened some of these areas, decide where the sun needs to go. In this case, the sun is directly behind the cabin and about three inches (8cm) above it. With the same brush and paint mixture, dab in an opaque sun. Be sure to apply the paint heavily so the color will stay nice and bright.

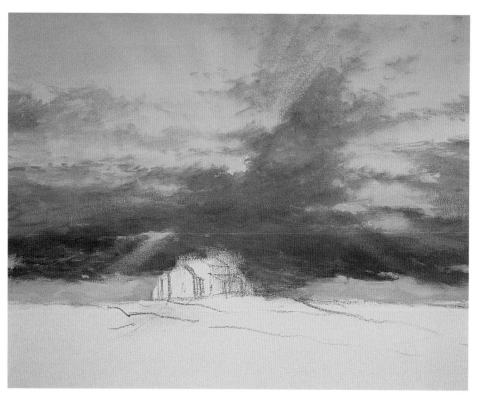

5 Add Sunrays

For the sunrays, take the mixture from step 4 and add about half as much gesso. Load a very small amount on the tip of your no. 6 bristle brush. Start at the location of the sun. With a dry-brush stroke, carefully scrub in the sunrays. The sunrays need to be very soft and transparent, which is why you use only a small amount of paint with a dry-brush stroke. Notice how the rays spread out 360 degrees around the sun. Most of the rays go all the way out to the edge of the canvas.

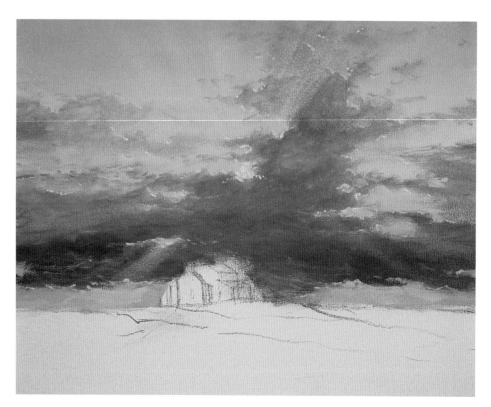

6 Add Silver Linings

This step is pretty easy (which is a problem for those of us who have a tendency to overdo some of the easier things). All you do is create a mixture of half Cadmium Yellow Light and half gesso. Load your no. 4 round sable brush fairly heavily, then paint the edges of the clouds using short, choppy strokes. You don't want a hardedged outline, so make sure the lines are broken.

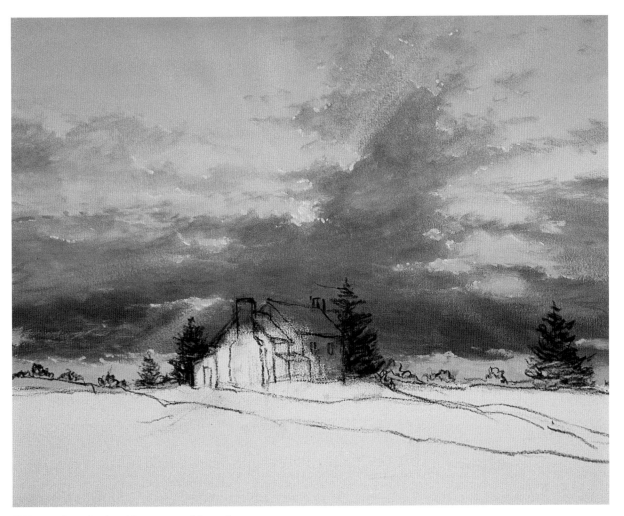

7 Resketch the House and Landscape

Take your soft vine charcoal and resketch the house and landscape. At this point, I decided to change the design of the house. No special reason; I just like this design better. Don't be afraid to make some changes of your own.

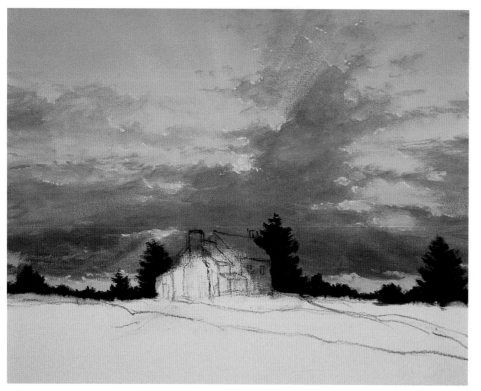

8 Paint Background Trees

For the background trees, create a mixture of four parts Hooker's Green, two parts Burnt Sienna and one part Dioxazine Purple. This color needs to be very dark. Experiment with the mixture until you're satisfied with the color and value. You'll notice that cedar trees are very wide at the base and taper as they go up. The best brush to use in this case is your no. 4 bristle brush. Start at the base of each tree and scrub in the shape, gradually working your way up and outward. Keep the edges fairly irregular, with interesting pockets of negative space between the limbs. After you have painted in the cedar trees, paint the small bushes along the horizon line.

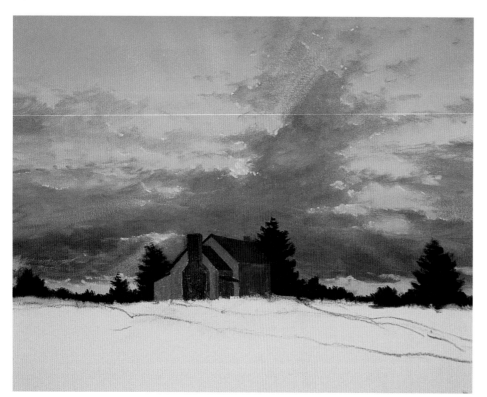

9 Underpaint the House

Create a mixture of four parts Burnt Sienna, one part Ultramarine Blue and a touch of Dioxazine Purple. As you block in the house, add touches of gesso to vary the values and tones. Next, block in the front and back of the cabin with your no. 4 flat sable. Don't be afraid to add touches of gesso or even a touch of Burnt Sienna, Ultramarine Blue or Dioxazine Purple as you go. The overall effect should be a fairly dark value. For the roof, add a touch of gesso to the mixture, then block in all the roof sections.

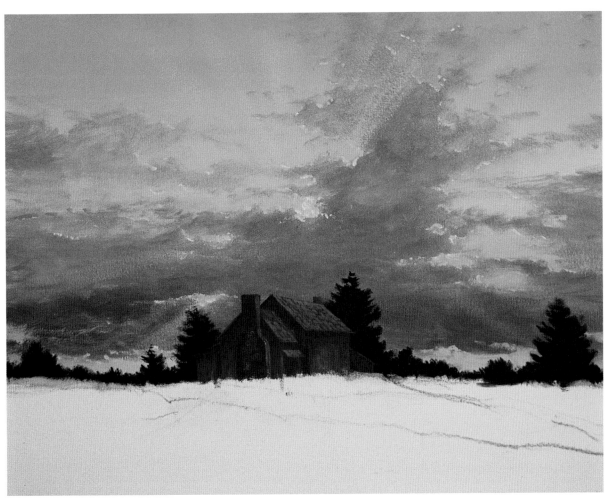

10 Detail the House

In this step, you get to use your artistic license. Just have fun putting in the details that make you happy. Add a little Cadmium Orange and gesso to the base color from step 9 to create a warmer, lighter value. Load a small amount on the end of your no. 4 flat sable, then drybrush in a few boards, either vertical or horizontal. This would be a good time to paint the stones on the chimney, block in any other doors or windows and basically straighten up any edges that are out of square. While you do have artistic license here, don't abuse it by going overboard on the details.

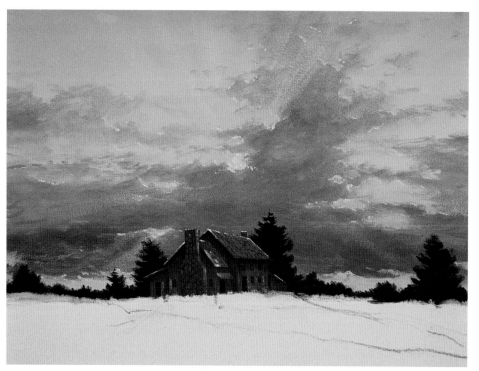

11 Highlight the House

Begin with the light in the windows. Mix Cadmium Yellow Light with a touch of Cadmium Orange. With your no. 4 round sable, dab this color on the windows, keeping it thick; thick, opaque paint generally remains bright. Create a mixture of gesso with touches of both Cadmium Orange and Ultramarine Blue. Paint an accent highlight on the edges of the roof line with your no. 4 flat sable; you could even drybrush some of this color on the roof to suggest shingles. Smudge a touch of this color in the chimney smoke.

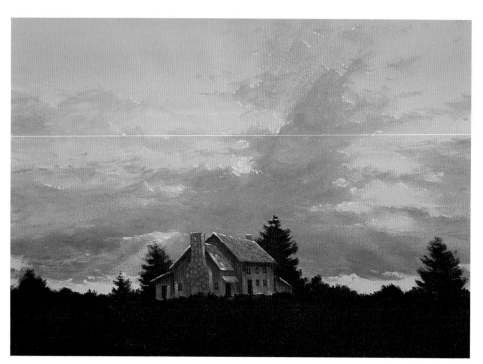

12 Underpaint the Middle Ground and Foreground

This step should be loose and semi-impressionistic. Create a dark base mixture of four parts Hooker's Green, two parts Burnt Sienna and one part Dioxazine Purple. Use your no. 10 bristle brush to scrub this color throughout the middle and foreground. Add touches of gesso as you go to change the value here and there. It's important to use bold brushstrokes; they'll help contours the ground. Also be sure to apply the paint fairly heavily to ensure complete coverage of the canvas.

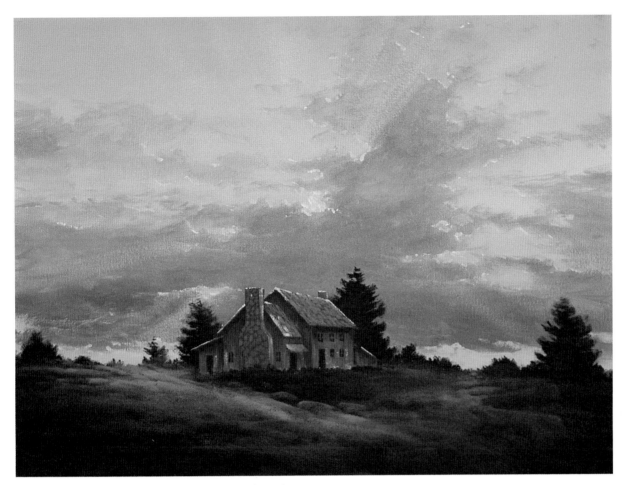

13 Highlight the Middle Ground and Foreground

Here, you want to create the contour of the sloping ground. You'll need your no. 4 or no. 6 bristle brush for this step. Create a mixture of Cadmium Yellow Light and touches of Cadmium Orange and gesso. Load just a small amount on your brush, then add enough water to make the mixture a little more transparent. Scrub in the contours of the ground until you are satisfied with the composition. The transparency of this mixture allows the background color to show through, which softens your strokes and makes them look more like dirt.

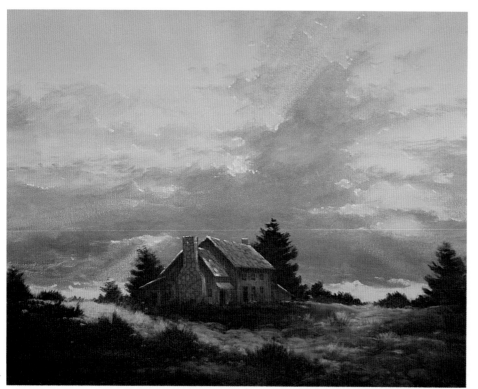

14 Add Bushes to the Middle Ground and Foreground

Create a mixture of about two parts Hooker's Green, two parts Burnt Sienna and one part Dioxazine Purple. This color should be similar to that of the background cedar trees. Load a small amount on the end of your no. 6 bristle brush, then drybrush in a variety of small bushes throughout the middle ground. At this point, you can drybrush in some lighter bushes against the darker areas of the middle ground. For this, create a mixture of two parts gesso, one part Cadmium Yellow Light and one part Cadmium Orange, using the same no. 6 bristle brush to paint in the lighter bushes.

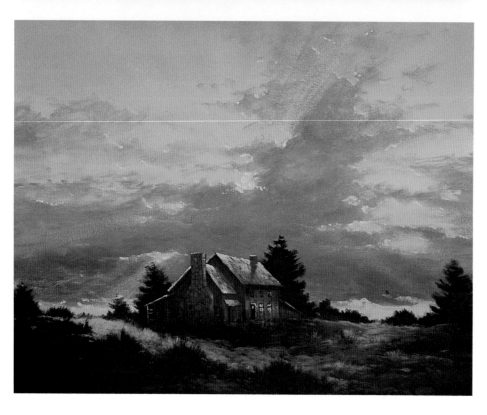

15 Final Highlights on the House

Here, you mainly want to add a little more of a sunlit glow to the house. Mix gesso with touches of Cadmium Yellow Light and Cadmium Orange. You may need to use several different brushes, depending on what area you are trying to highlight. For instance, if you want to put an accent edge on the roofline, use your no. 4 script liner. To drybrush a few brighter highlights on the roof, use your no. 4 flat sable. The no. 4 round sable works well for squaring up the doors and windows.

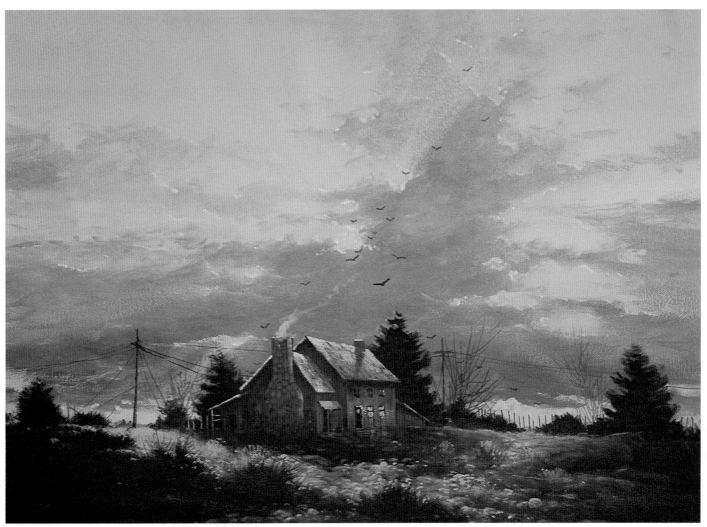

16 Add the Final Highlights

Create a mixture of gesso with touches of Cadmium Orange and Cadmium Yellow Light. Load a small amount on your no. 4 flat sable. Throughout the middle ground, where the sunlight is hitting the ground, drybrush in the suggestion of rocks and pebbles. If the color is too bright, just add a little water to the mixture to make it more transparent. This will allow the background color to show through, toning down the highlight slightly. Notice that most of these rocks and pebbles are in the center of the middle ground. Keep the corners of the painting darker and less detailed. Finally, liven up the painting by adding a few details with your no. 4 script liner, like the leafless background trees, the telephone pole and the flying birds. Use gesso to add a smudge of smoke rising from the chimney.

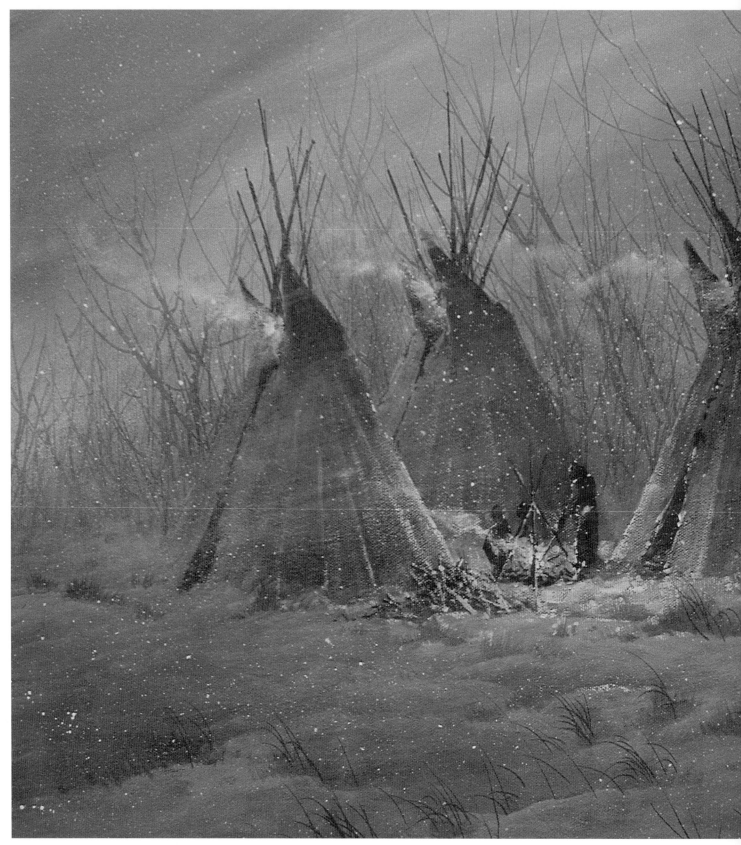

Campfire
16" × 20" (41cm × 51cm)

Campfire

One of my favorite types of lighting is glowing light. Campfire is a wonderful example of how a glowing light works. Earlier, we discussed the effects of glowing light and how different they are from those of a direct light source such as a sunray or headlight. Glowing light is usually a soft, warm light that gently radiates from its source. It works best in a dark atmosphere, where it illuminates only those objects immediately surrounding the source. In this case, the campfire is surrounded by darkness and the rich, warm light highlights only the objects and people nearby. Glowing light can be challenging; if you're going to do a painting like this, you need to be patient. Achieving the level of brightness that you see here usually takes several layers of paint. So grab your brushes and let's get started!

1 Underpaint the Background

For this painting, don't start with a sketch; paint the background first and *then* do the sketch. To paint the background, first lightly wet the background with your hake brush. Next, apply several colors simultaneously; start with gesso, then stroke in Ultramarine Blue, Burnt Sienna and Dioxazine Purple. Use long, broad-angled strokes to indicate blowing wind. You want to end up with a medium-dark grayish tone. Don't be afraid to experiment with different amounts of these colors to get the right effect. Overblending might create a solid gray background, so leave some of the streaky appearance.

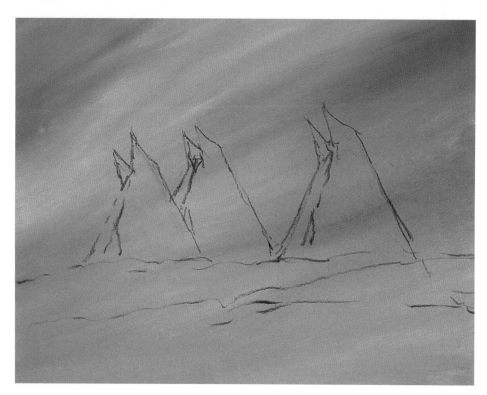

2 Sketch the Teepees

Make a rough outline of the basic structure of the teepees and the ground using your vine charcoal. Be sure the teepees are in proportion to their location in the painting.

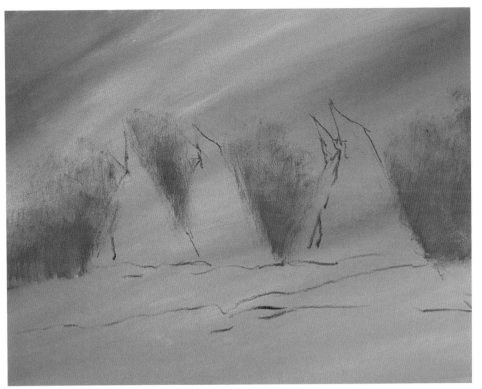

3 Underpaint the Forest

Your first value change will take place in this area. You want it to be about two shades darker than the sky, so create a mixture of about four parts Ultramarine Blue, two parts gesso, one part Burnt Sienna and one part Dioxazine Purple. Keep in mind that these mixtures are not exact, so experiment until you get the right color and value. Once you've achieved the right mixture, scrub the color into the forest background with your no. 10 bristle brush. Keep the forest's top edge soft and smudgy. Notice that this area has an irregular shape.

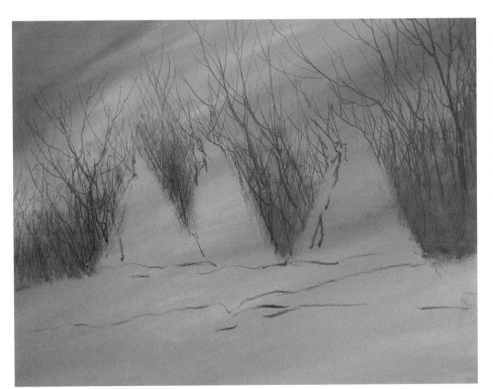

4 Paint the Trees

Darken the color from the previous step slightly by adding a little more Burnt Sienna, Ultramarine Blue and Dioxazine Purple. Thin this to an inklike consistency, then load your no. 4 script liner brush with this mixture. Paint in the trunks and branches by starting at the ground and dragging the brush up. The trees are all different sizes and heights, so don't get locked into repeating the same tree over and over. The trees also lean slightly to the left, which gives the impression of blowing wind.

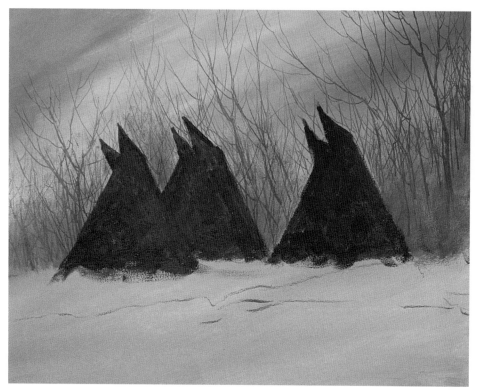

5 Underpaint the Teepees

For this step, you'll need your no. 6 or no. 4 bristle brush. Create a mixture of about half Burnt Sienna and half Ultramarine Blue, then add just a slight touch of gesso. The color should end up with a slight brownish tint. Now, paint in all three teepees, making sure that the canvas is well covered. For the flaps at the top of the teepees, you'll need to darken the mixture with a little more Ultramarine Blue and Burnt Sienna. Gradually blend this darker color into the main body of the teepees to avoid a hard edge between the two colors.

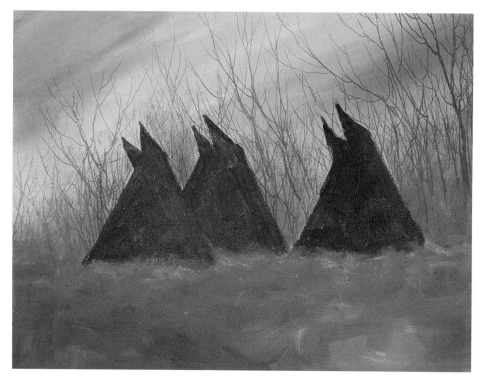

6 Underpaint the Snow

To underpaint the snow, create a deep grayish purple by mixing four parts gesso, two parts Ultramarine Blue, one part Burnt Sienna and one part Dioxazine Purple. Make the mixture fairly creamy. Use your no. 10 bristle brush to completely cover the entire middle ground and foreground. Scrub a soft edge up against the background trees and the bases of the teepees to help ground them and create the softness of drifted snow.

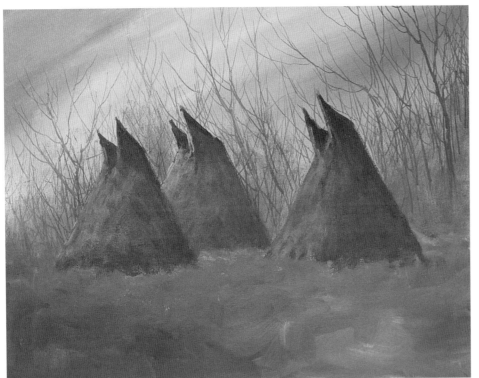

7 Highlight the Teepees

Highlighting the teepees will make them a little more three-dimensional, but the highlights shouldn't be too strong or detailed. Load your no. 4 or no. 6 bristle brush with a mixture of Burnt Sienna and slight touches of Cadmium Yellow Light and Titanium White. Begin painting on the side of the teepees that face the campfire. Scrub in a soft highlight, gradually fading it across to the dark side. You want only a slight suggestion that these teepees have a three-dimensional form.

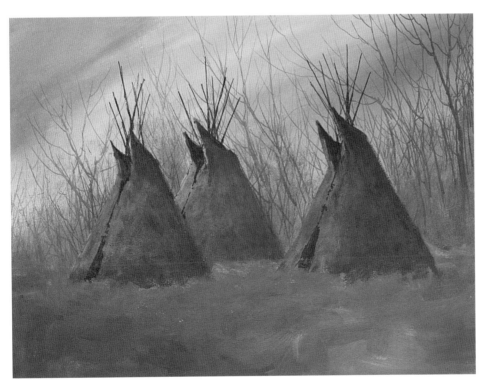

8 Paint the Lodge Poles and Doors

Create a mixture of equal amounts of Ultramarine Blue and Burnt Sienna. Block in the openings for the doors and at the tops of the teepees with your no. 4 round sable brush. It would probably be a good idea to sketch in the lodge poles with soft vine charcoal first, just to be sure you're happy with their location and length. Once you're satisfied, paint them in with your no. 4 round sable or no. 4 script liner brush.

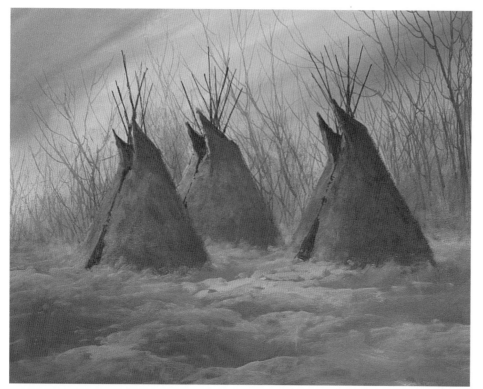

9 Highlight the Snow

Mix gesso with a touch of Cadmium Orange and enough Ultramarine Blue to really gray it. Thin this mixture so that it has an almost washlike consistency. Load a small amount on the end of your no. 6 bristle brush, then scrub in the contour of drifted snow throughout the middle ground and foreground. You want soft, drifted mounds of snow, so be careful not to overdo it. Drift snow up against the bases of the teepees.

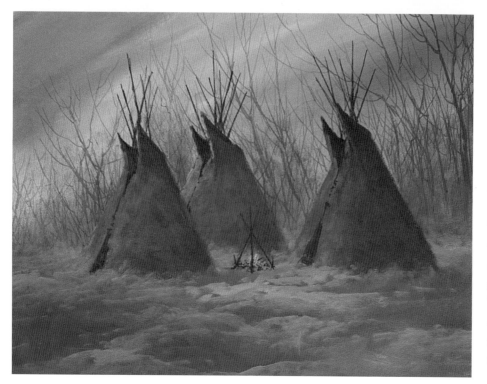

10 Paint the Campfire

OK, this is where the painting begins to get interesting! First, create a mixture of equal parts Burnt Sienna and Ultramarine Blue. Use your no. 4 round sable to paint the sticks that make up the campfire at the base of the tripod, then paint in the tripod. Clean out your brush, then mix equal amounts of Cadmium Orange and Cadmium Yellow Light. To create the suggestion of fire, dab in this yellow-orange color with your no. 4 round sable. While this color is on your brush, go ahead and highlight the edges of the tripod (not too much, though, since most of the highlighting will come later).

11 Add the Campfire's Glow
Mix about three parts Cadmium Orange with one part Cadmium Yellow Light, then add just enough gesso to opaque the color. Load the end of your no. 4 flat sable with the mixture, then carefully scrub in the color to suggest the fire's glow. Focus on the ground around the campfire, adding a little bit up the sides of the teepees. The glow is concentrated mostly in the center area, so don't spread the light too far out into the middle ground.

12 Add the Figures
Before you paint the figures or the woodpile, sketch them in with your soft vine charcoal. Use a mixture of equal parts Ultramarine Blue and Burnt Sienna and your no. 4 round sable brush to paint in the figures and the woodpile in front of the left teepee. Keep in mind that the figures are only silhouettes, so keep the shapes simple.

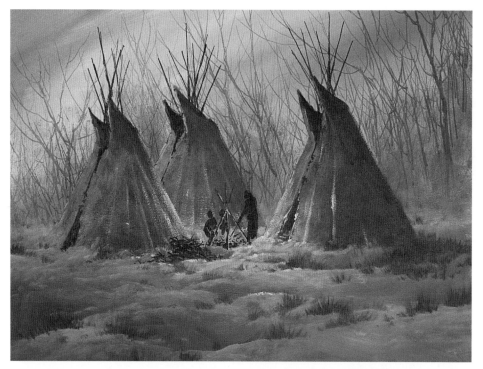

13 Paint the Clumps of Grass

As fillers, the clumps of grass are very important in completing the foreground. Create a mixture of Burnt Sienna with a touch of Ultramarine Blue, a touch of Dioxazine Purple and a bit of Titanium White to soften it. With your no. 6 bristle brush, drybrush these clumps of grass throughout the middle ground and foreground. Keep the clumps of grass soft and undetailed so they don't compete with the center of interest. None of these clumps should stick out; if they do, try lightening the value.

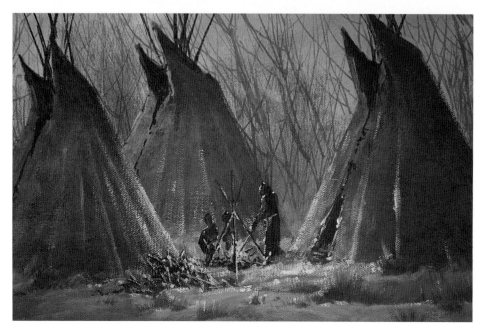

14 Add More Highlights

Start with a mixture of about three parts Cadmium Orange, one part Cadmium Yellow Light and a bit of gesso. Load your no. 4 round sable fairly heavily. The effect you want here is similar to a silver lining. As you apply this glowing highlight to the edges of the objects, don't smudge it; let it glide off the end of the brush with a light touch. You'll have to reload your brush frequently to keep the paint fresh and clean.

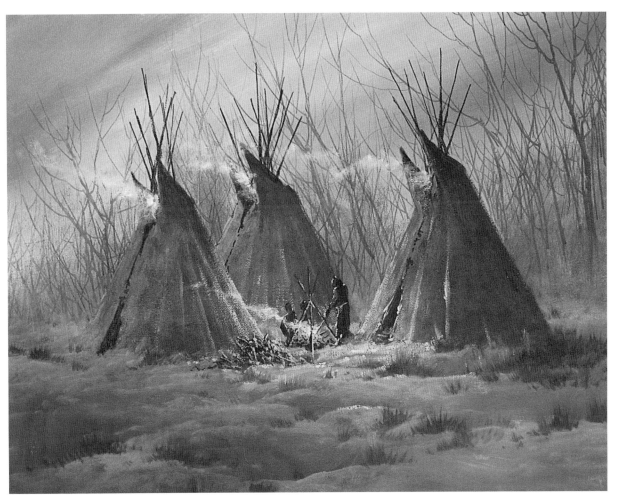

15 Paint the Smoke

This step is simple and quick. Tint gesso by adding touches of Burnt Sienna and Ultramarine Blue. Load a small amount on the very tip of your no. 4 bristle brush. Smudge the color from the top of each teepee and from the fire in an irregular pattern. Make the smoke drift to the left so it will add to the effect of the blowing wind. Avoid making the smoke too opaque; you want a soft, wispy look.

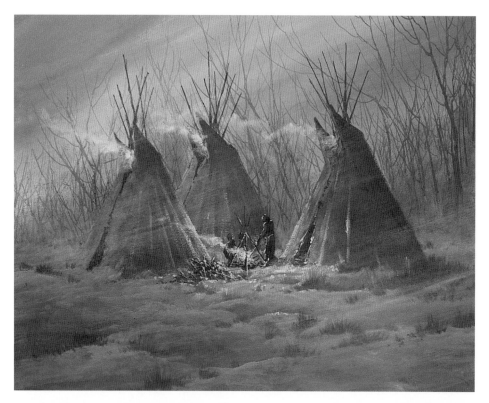

16 Add Blowing Snow

For this step, you'll need your hake brush. First, lightly wet the entire painting, then load a little bit of gesso all the way across the end of the hake brush. Drag the brush lightly across the entire painting at an angle that suggests the blowing of the wind. This should create a very transparent effect. When the gesso dries, it may not show up as much as you would like. If that's the case, don't hesitate to repeat this step.

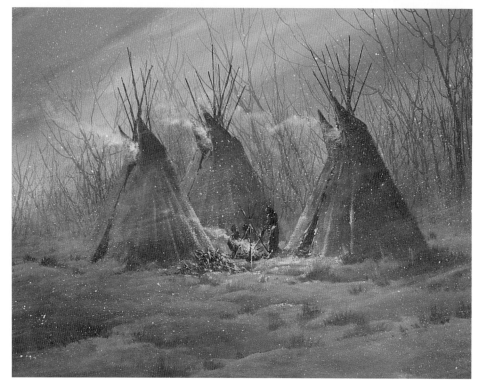

17 Paint the Snowflakes

For this step, you'll need your hake brush and a toothbrush. Lightly wet the entire canvas with your hake brush, then quickly mix gesso and water together using the toothbrush. (This white mixture should be very soupy.) While the painting is still wet, hold your toothbrush about six inches (15cm) from the canvas and run your thumb across the bristles. This will spatter irregular little drops of paint on the canvas. The splatters will bleed a little, which makes them look like soft snowflakes. (You might want to practice this technique first on a scrap of canvas.)

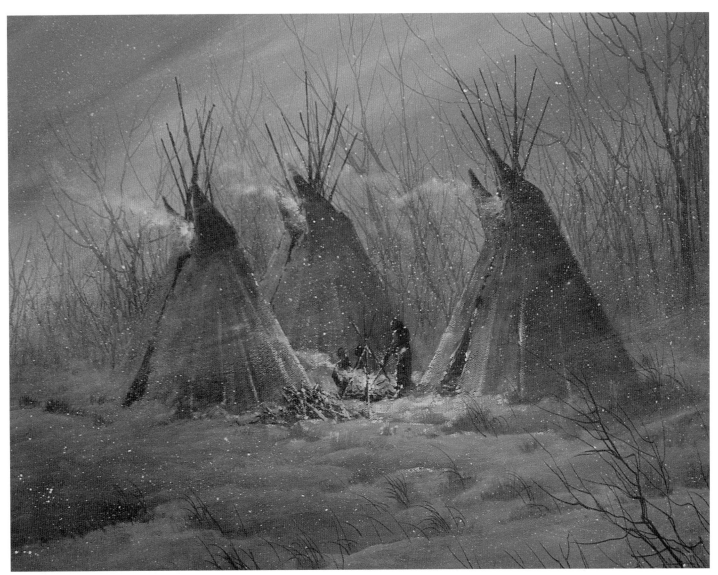

18 Add the Final Details

Add the few details and highlights that give the painting its finished look. For instance, the glow around the campfire might need to be a bit brighter, so mix about three parts Cadmium Orange with one part Cadmium Yellow Light and a touch of gesso, then repeat step 14. To add a dead bush in the lower right corner, mix together three parts Burnt Sienna and one part Ultramarine Blue. Thin the mixture to an inklike consistency, then paint in the bush with your no. 4 script liner brush. Look at the painting and make any adjustments you think might benefit the composition, color or value system.

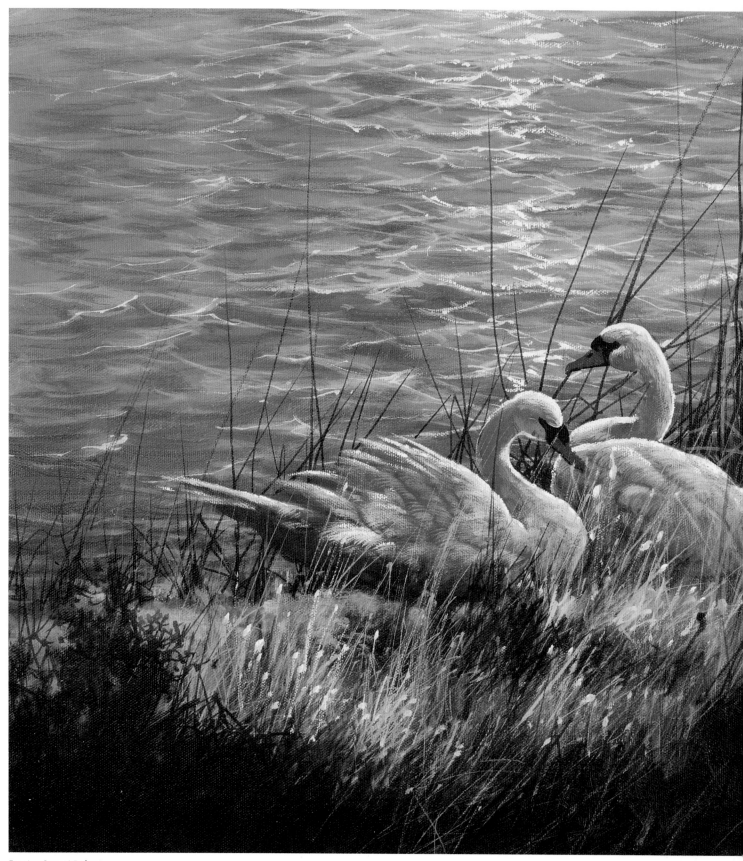

Evening Swans' Refuge
16" × 20" (41cm × 51cm)

Evening Swans' Refuge

What a dramatic impact light has on a painting like this! In the opening instructions, we discussed a type of lighting called backlighting. In a backlit painting, the light source is directly behind the object of interest, illuminating it with a bright, dramatic accent highlight on the outer edge, often referred to as a silver lining. When I was researching waterfowl years ago for another painting, I stumbled across these two swans nestled against a shallow bank with the vivid light behind them. They were the perfect subjects for studying backlighting. The silver lining edging their forms was intense and the silver lining on the ripples of water was so bright it actually hurt my eyes. This type of lighting situation is an artist's dream come true—so get out your sunglasses and let's go to work!

1 Underpaint the Water

This step is really fun and loose. Starting at the top of the canvas, apply liberal coats of gesso with your no. 10 bristle brush, using broad, horizontal, choppy strokes. Apply small amounts of Ultramarine Blue and Hooker's Green, blending them into the gesso. Don't overblend or you'll lose the choppiness of the water. As you work your way down, darken the value with more Ultramarine Blue and Hooker's Green. When you're finished, the water should be lighter at the top and gradually darken as it comes down. You should also be able to see light and dark pockets scattered throughout.

2 Underpaint the Ripples

The main goal here is to establish the ripples. First, create a creamy mixture of equal parts gesso and Ultramarine Blue, then add a touch of Burnt Sienna to gray it. It doesn't take much paint to underpaint the ripples, so load only a small amount on the end of your no. 4 bristle brush. Lightly skim your brush across the water, beginning at the top and moving down, but always keeping these strokes horizontal and fairly irregular. The irregular pattern is what makes the water look like it has movement.

3 Define the Ripples

Once you've established the irregular pattern of the water's movement, slightly tint some gesso with Ultramarine Blue. Thin this mixture, but not quite to the inklike consistency we often make. Use this mixture and your no. 4 round sable to paint along the top edge of the irregular patterns you created. This will accent and define the ripples.

4 Highlight the Ripples

This final highlighting must be completed before painting in the grasses and swans. Use either gesso or Titanium White. Load your no. 4 round sable brush heavily, then, with a very light stroke, skim the white across the edges of the ripples. Allow the paint to just slide off the brush so that the white is very thick and opaque. Notice that this highlight is mostly concentrated toward the center of the water area; this gives the effect of moonlight glowing on the water. Don't overhighlight or spread this highlight too far toward the edges of the canvas.

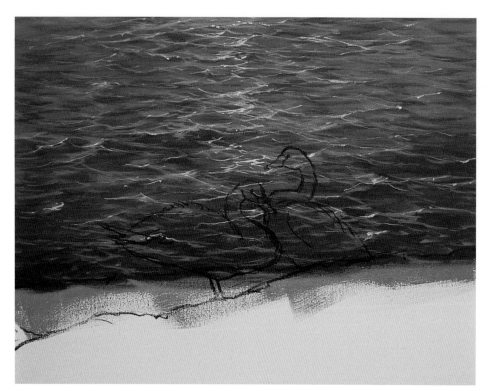

5 Sketch the Swans and Shoreline

Now that you have the underpainting complete, take your soft vine charcoal and make an accurate sketch of the swans. It's important that your sketch is just the way you want it because once you have painted the swans, it's difficult to make major corrections.

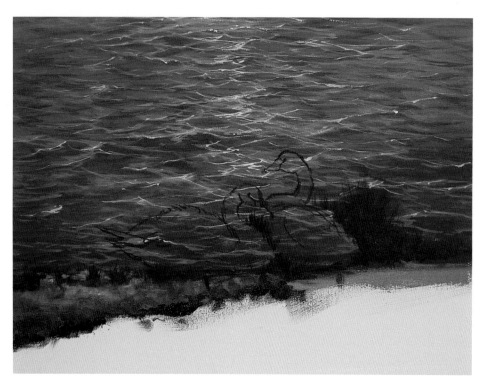

6 Underpaint the Shoreline

You should get the grass in before painting the swans. First, create a mixture of two parts Hooker's Green with one part Burnt Sienna and one part Dioxazine Purple. Now use your no. 6 bristle or your no. 10 bristle to scrub in a soft underpainting to serve as the background for the grasses. Paint this across the shoreline and in the area just behind the swans. Don't get carried away making the area behind the swans too tall; it's just a base for the taller grasses in step 8.

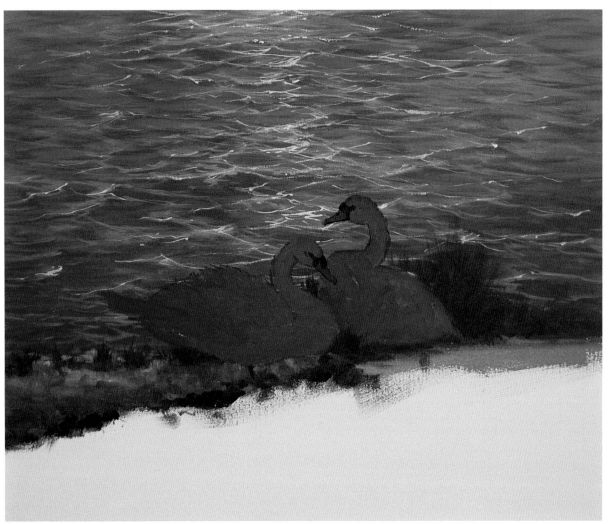

7 Underpaint the Swans

Create a mixture of three parts gesso and one part Ultramarine Blue with small dabs of both Dioxazine Purple and Burnt Sienna. This should create a medium-tone gray. I prefer this to be just slightly on the purple side, so don't hesitate to add a little extra Dioxazine Purple. Make the mixture creamy; then, using either your no. 4 flat sable or your no. 4 flat bristle, simply underpaint both swans. Where the swans are darker at the base, add more Burnt Sienna and Ultramarine Blue to the mixture. Be careful not to end up with a hard edge on the swans; keep the edges soft.

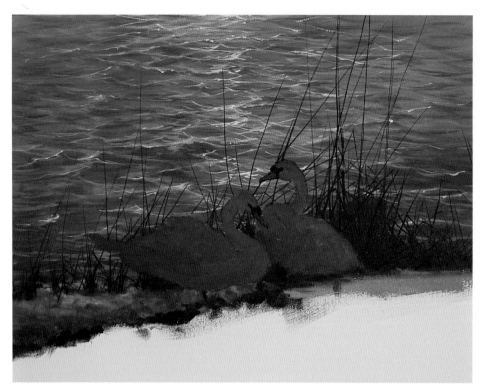

8 Paint the Reeds

For this step, use the dark green mixture from step 6. Thin the mixture to an inklike consistency. Roll your no. 4 script liner brush in the mixture until the brush forms a point, then paint in the tall reeds behind the swans. Vary the lengths of the reeds, overlapping some. This variety helps create good eye flow and helps break up large pockets of negative space.

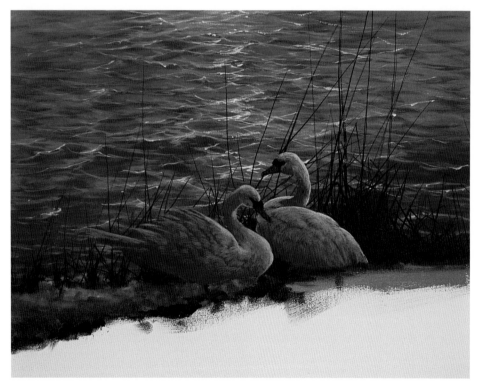

9 Paint the Feathers

This step may be a little challenging, but it's definitely worth the effort. You'll need your no. 4 flat sable brush for this step. There's no exact formula for this; I'll explain the technique, but you'll have to experiment until you feel comfortable with it. First, tint some gesso with a touch of Cadmium Orange, making the mixture creamy. Load a small amount on the end of your brush, then carefully use a light drybrush stroke to paint in the feathers, following the contour of the swan's body. You'll only know how the feathers follow the swan's contour by carefully studying your reference material. It takes practice to acquire the eye-to-hand coordination necessary for these feathers.

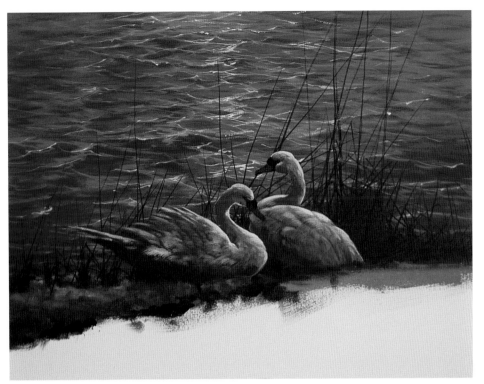

10 Highlight the Swans

Once you've established the contour of each swan, highlight the feathers using a brighter value. This requires the mixture you used in step 9 (gesso tinted with a touch of Cadmium Orange). Load your no. 4 round sable fairly heavily with the mixture. Using a very light dry-brush stroke, carefully highlight the outer edges of the swans to create the silver lining. Also highlight some of the raised areas of the feathers within the body area.

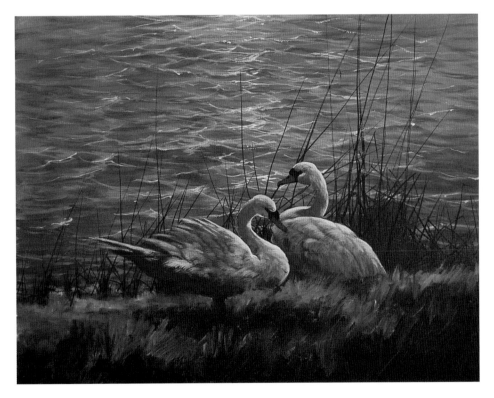

11 Underpaint the Foreground

For this step, you want to be loose and impressionistic. First, double load your no. 10 bristle brush with Burnt Sienna and Dioxazine Purple. Scrub this color along the shoreline and the base of the swans to suggest the ground. While this is still wet, add touches of Cadmium Orange and gesso to add a few light and dark spots to the ground. Scrub Burnt Sienna, Hooker's Green and Dioxazine Purple into the painting, using choppy, vertical strokes to mix the colors throughout the foreground. Don't be afraid to add touches of Cadmium Yellow Light, Cadmium Orange or Thalo Yellow-Green to create a few lighter areas.

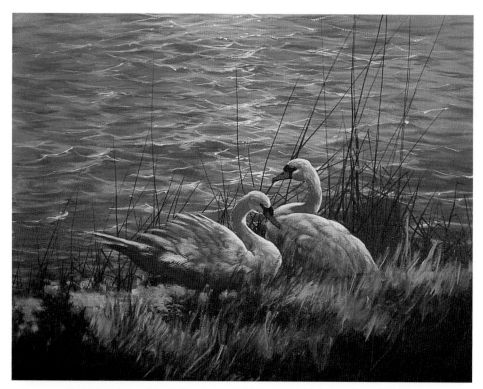

12 Detail the Foreground

The foreground is fairly rough and primarily one tone, so add some brighter moonlit areas. Double load your no. 10 bristle brush with Cadmium Orange and Thalo Yellow-Green. Carefully but quickly scrub these two colors vertically throughout the foreground to create bright pockets of moonlight. To highlight the sandy area to the left of the swans, mix gesso with a touch of Burnt Sienna and a touch of Cadmium Orange, then load a small amount on your no. 4 bristle brush and scrub in a few highlights to suggest dirt or sand.

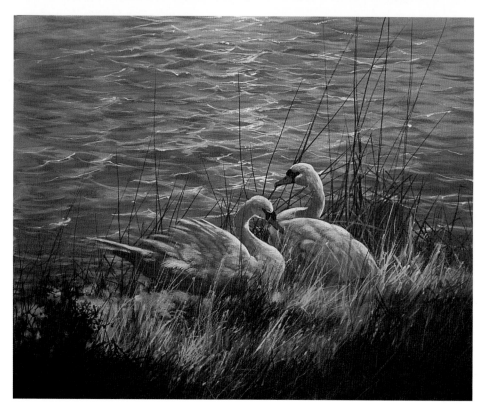

13 Add Foreground Grasses

This step and the next step are very similar. You'll need your no. 4 script brush and two color mixtures. First, create a light mixture of three parts Thalo Yellow-Green and one part Cadmium Orange. The second mixture will be dark, about two parts Hooker's Green, two parts Dioxazine Purple and one part Burnt Sienna. Thin both mixtures to an inklike consistency. First, paint in a wide variety of light grasses that contrast against the dark areas. Next, paint in a wide variety of *darker* weeds that contrast against the *light* areas. Let a few overlap in front of the swans.

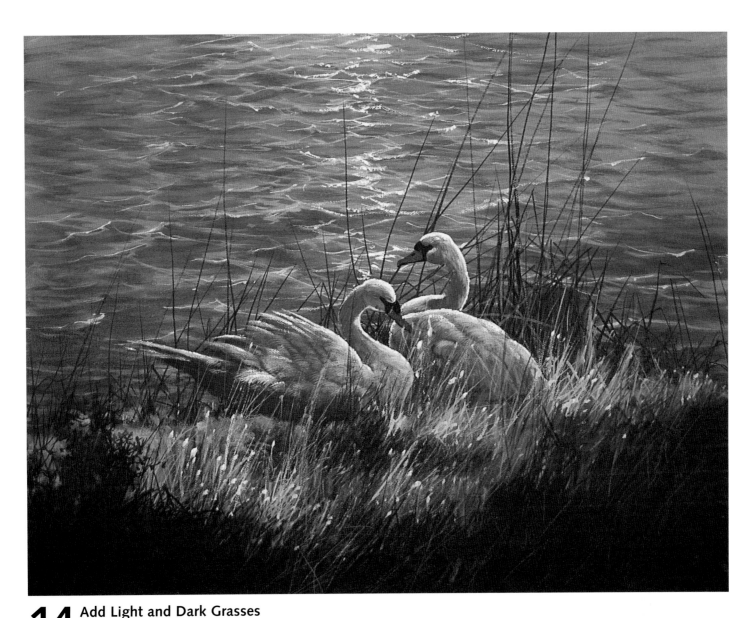

14 Add Light and Dark Grasses

This step is very similar to the last, except in order to achieve the moonlit glow, you need to use purer colors. Pure yellow is the key color here, so thin Cadmium Yellow Light a bit, then paint in several bright yellow grasses that contrast against the darker areas. You can create other mixtures such as Cadmium Yellow Light mixed with Thalo Yellow-Green or Cadmium Yellow Light mixed with a little gesso, even Cadmium Yellow Light mixed with Cadmium Orange. Experiment to come up with some bright, clean colors. Then, with a dark green mixture of half Hooker's Green and half Dioxazine Purple, paint a few darker grasses and the bush in the left foreground. Acrylics usually dry a darker color than their wet versions. In a painting like this one, the extreme bright light is critical to the overall success of the painting. You'll probably have to repeat some of the extreme highlights a few more times to achieve the intensity you want. I recommend you go over the brighter highlights on the ripples of the water, the highlights on the swans and also the brighter weeds. You'll be glad you did this.

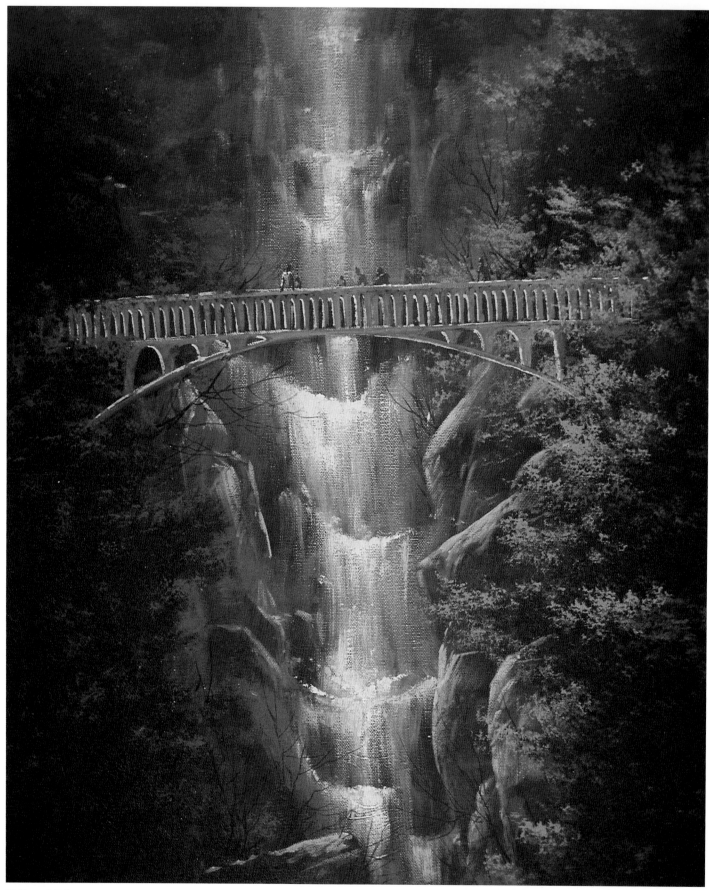

Multnomah Falls
20" × 16" (51cm × 41cm)

Multnomah Falls

Multnomah Falls is truly a sight to behold. A few years ago, I held a workshop on the Columbia River in Oregon. Early one morning, I decided to take a short research trip to study some of the numerous waterfalls along the river. It certainly didn't take long for me to see the attraction of Multnomah Falls. And guess what? Light plays a major role in the awesome, overwhelming power and artistic majesty of this magical place. It's an artist's playground. What makes this subject so special is not just its sheer size, sound and the constant cool mist that surrounds the falls, but also the light that filters through the canopy of trees and surrounds the cascade. The light changes throughout the day, changing the falls with it. On occasion, a beautiful full-color rainbow will appear. Light is the key component in appealing works of art; light gives this waterfall life.

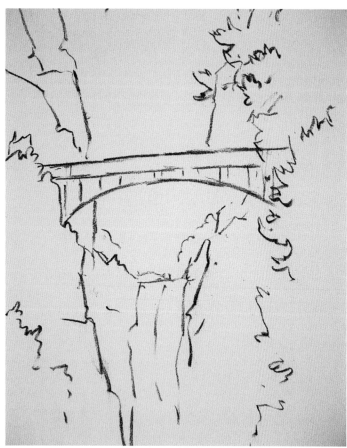

1 Sketch in the Basics

Make a rough sketch of the composition's main components with vine charcoal. Don't worry about sketching the perfect bridge; that comes later.

2 Underpaint the Waterfall

Whenever you have a white object in a painting such as a white dress, a white tablecloth, a white bird or, in this case, a waterfall with white water, you usually underpaint with a bluish or purplish gray background. For this waterfall, mix together two parts gesso, two parts Ultramarine Blue and one part Dioxazine Purple with just a small amount of Burnt Sienna. This should create a medium purplish gray. Completely paint in the area where the waterfall is going to be with your no. 10 bristle brush. Use plenty of paint; make sure the canvas is well covered.

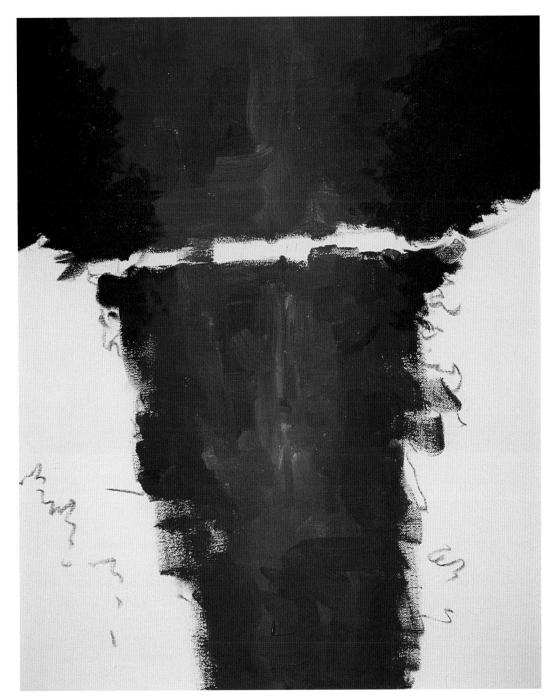

3 Underpaint the Foliage

Make a dark green mixture of two parts Hooker's Green, two parts Dioxazine Purple and one part Burnt Sienna. Underpaint the area on each side of the waterfall just above the bridge with your no. 10 bristle brush. Keep in mind that this is only the underpainting, so you want to use loose, impressionistic strokes. Be sure the canvas is completely covered and the waterfall's edges are soft and irregular.

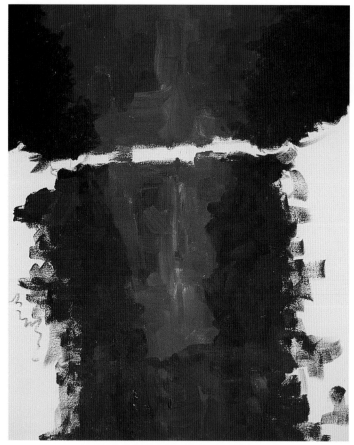 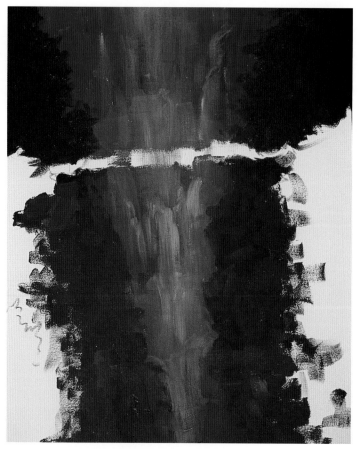

4 Underpaint the Rock Formations

As in step 3, this is only an underpainting, so use loose brushstrokes with your no. 10 bristle brush. Since you'll do all the mixing on the canvas, just pick up the colors from your palette and apply them quickly. You want to apply the paint fairly thickly to create a bit of texture. Start by scrubbing Burnt Sienna in the rock area. While this is still wet, add Ultramarine Blue, touches of Dioxazine Purple and touches of gesso. The key here is to mottle all of these colors together on the canvas, creating a variety of subtle value changes as well as visible brushstrokes to suggest where rocks go. Don't overblend or it will become a solid color.

5 Start the Waterfall

Complete this part of the waterfall before going any further. First, create a creamy mixture of Titanium White with just a touch of Ultramarine Blue. This should just be a tint, so don't add too much Ultramarine Blue. Load a small amount of the mixture across the end of your no. 10 bristle brush. Start at the top of the canvas and work your way down, using a light dry-brush stroke. Keep your movements vertical and choppy. Apply the mixture carefully; if the paint is too opaque, it'll cover up the background and the waterfall won't have depth.

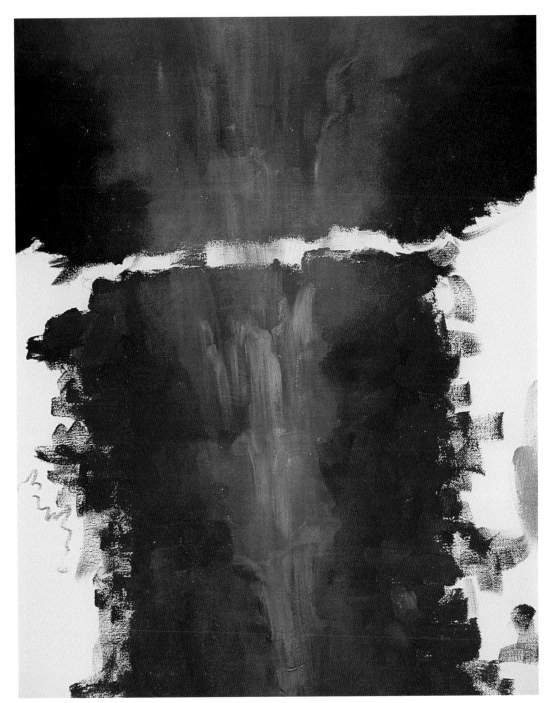

6 Scrub in the Mist

Use the mixture from the previous step, except darken it with a little more Ultramarine Blue and a touch of Dioxazine Purple. Load a small amount on the end of your no. 6 bristle brush and begin scrubbing in a soft transparent mist. You'll have better luck if you use a circular scrubbing motion with fairly heavy pressure. The goal here is to soften the edges of the waterfall and create a light mist, so don't make the mist too opaque.

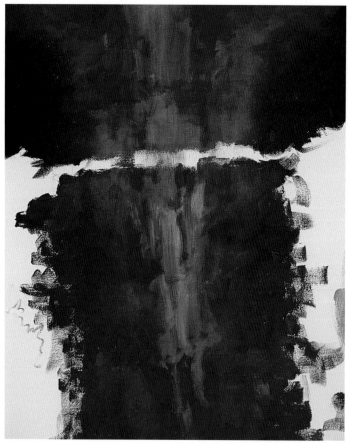 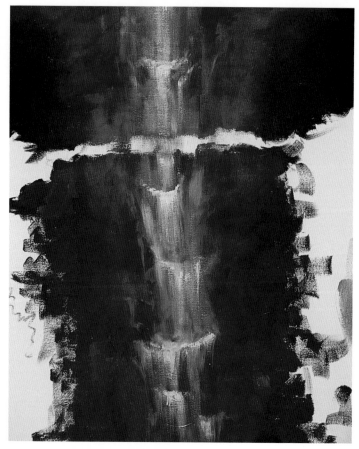

7 Add Dark Areas

This step is important for creating depth within the waterfall. Create a dark gray mixture by mixing two parts Ultramarine Blue, one part Burnt Sienna, one part gesso and a touch of Dioxazine Purple. Scrub in some dark areas throughout the waterfall with either your no. 6 or no. 10 bristle brush. These areas will represent rocks embedded in the waterfall; the contrast will help show the depth within the water.

8 Highlight the Waterfall

Create a creamy mixture of Titanium White with a touch of Cadmium Yellow Light. Once again, this is only a tint, so don't add too much Cadmium Yellow Light. Load a very small amount on the tip of your no. 10 bristle brush. Begin at the top of the waterfall. Using vertical, dry-brush strokes, work your way down. Notice the different layers stacked on top of each other, like shelves. Every time you create a shelf, put the paint on a little thicker and create a light depression. From this depression, drybrush the paint down to the next shelf and repeat this process all the way to the bottom of the waterfall.

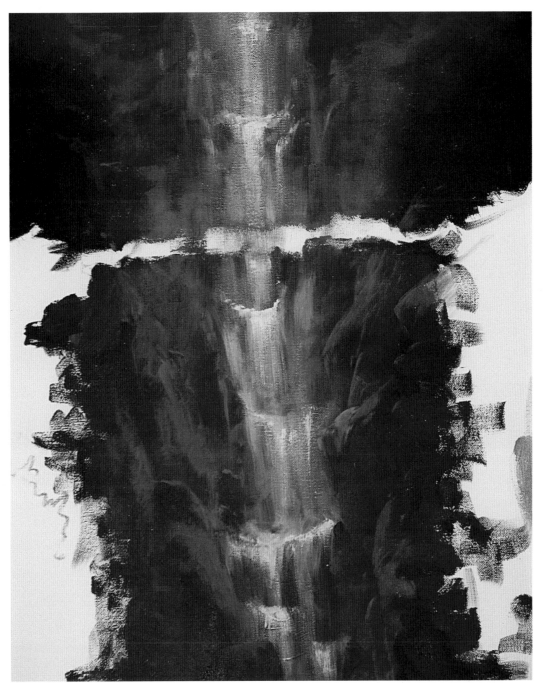

9 Form the Rocks

To create the main form of most of the rocks, you'll need an intermediate color. Mix equal parts Ultramarine Blue and gesso, then add a touch of Cadmium Orange to warm it up. Make the mixture nice and creamy. Use either your no. 4 or no. 6 bristle brush, loading only a small amount. This is where the earlier underpainting with the loose brushstrokes can really help. Search for these brushstrokes and then highlight them.

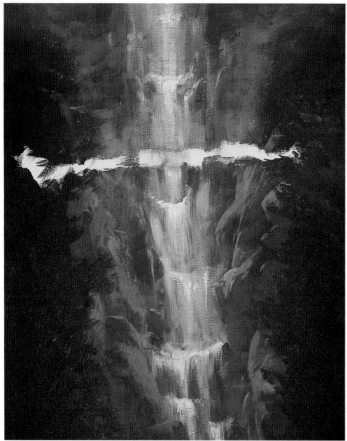 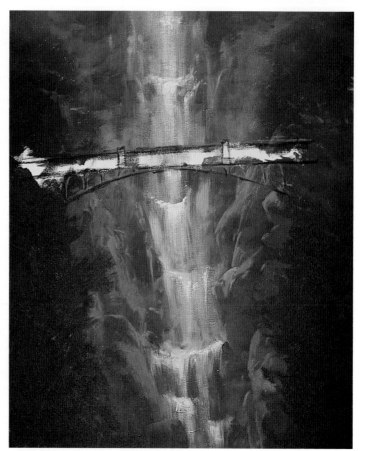

10 Underpaint the Trees

This step is identical to step 3. First, create a mixture of two parts Hooker's Green, two parts Dioxazine Purple and one part Burnt Sienna. Paint the area below the bridge and on each side of the rock formations with your no. 10 bristle brush. Once again, use bold, impressionistic strokes with irregular soft edges around the rocks. Be sure the canvas is well covered.

11 Sketch in the Bridge

Sometimes charcoal doesn't show up well on a dark background, so you can use light-colored chalk or a pastel pencil to sketch in the bridge. This sketch has to be fairly accurate, so take your time. Make sure you are pleased with the design, size, location and angle. Make any adjustments at this stage.

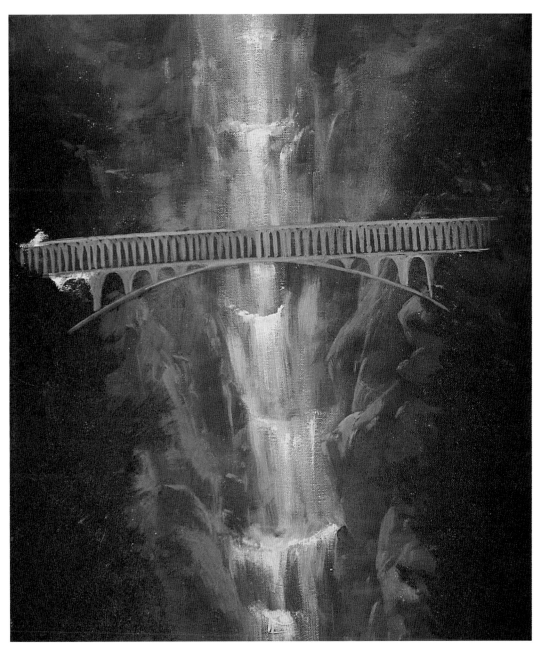

12 Underpaint the Bridge

The underpainting color is a medium gray made from two parts gesso, two parts Ultramarine Blue and one part Burnt Sienna. Make the mixture very creamy. You'll probably need your no. 4 round sable and no. 4 flat sable; use whichever one works best for the part of the bridge you are working on. Begin underpainting the bridge. This may take a while, but be patient. And be very sure you are satisfied with the overall design; it's easier to make minor adjustments now than later.

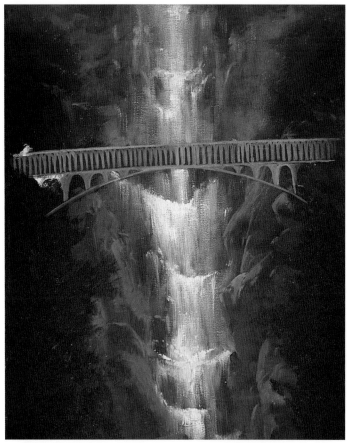

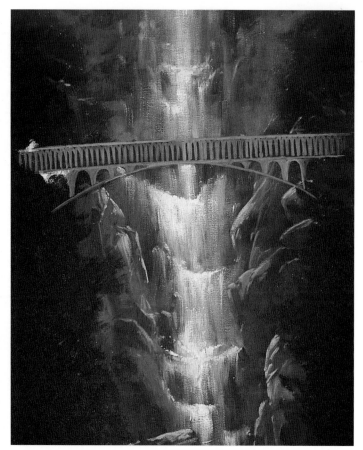

13 **Add the Waterfall's Final Highlight**
Either use pure gesso or Titanium White, adding a little water to make it creamy. Load the end of your no. 4 bristle brush fairly heavily. Dab this on the top of each shelf, then wipe your brush out. Next, use your brush to drag the wet paint at the top of each shelf downward in the center of the falling water. To avoid completely covering the underpainting, use a light dry-brush stroke.

14 **Add Final Highlights to the Rocks**
Create a creamy mixture of Titanium White with a touch of Cadmium Orange. This time, the mixture is more than just a tint, so add enough Cadmium Orange to give it a little color. The best brush for this final highlight is your no. 4 flat sable. Pick the rocks that you want to stand out most and highlight them first. Notice that each rock's highlight has a different value. You achieve this by making the mixture a bit more transparent and using smaller amounts of paint. The more opaque the highlight, the more intense it will be; the more transparent you make it, the less intense it will be.

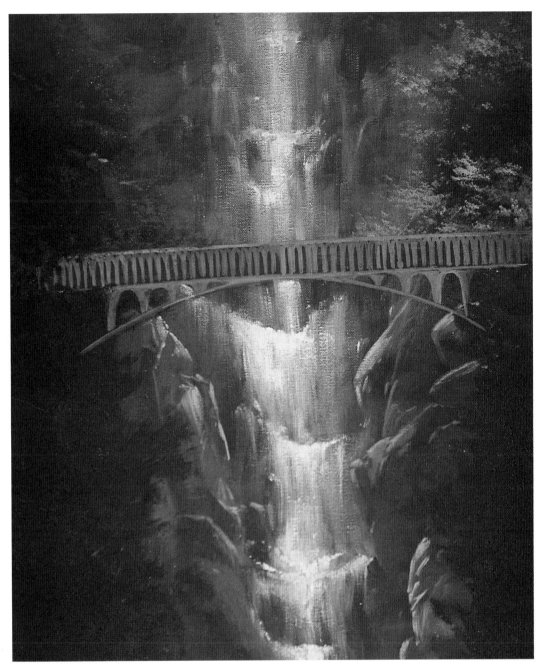

15 Highlight the Trees Above the Bridge

The highlights on the left side are less intense than they are on the right side; this helps to establish the direction of the light more distinctly. Dab brighter highlights on the right side of the waterfall with your no. 6 bristle brush. Mix Thalo Yellow-Green, Hooker's Green and Cadmium Yellow Light in any combination you want. Don't hesitate to add a touch of gesso to make whatever mixtures you come up with more opaque. For the left side, use a mixture of Hooker's Green with a bit of Thalo Yellow-Green.

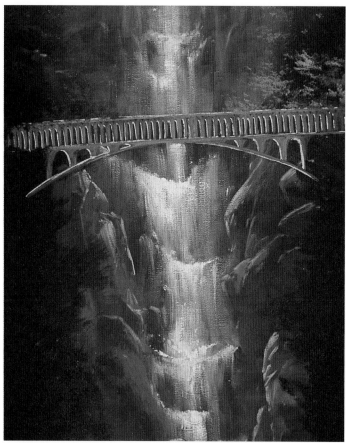

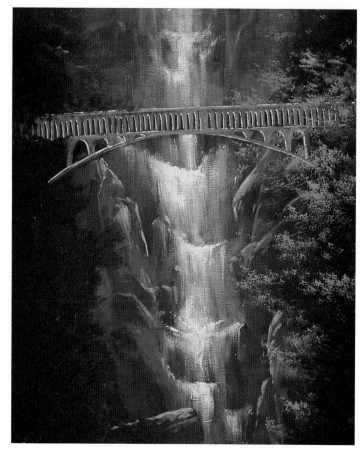

16 Highlight the Bridge

For this step, use either the no. 4 flat sable or no. 4 round sable, or both. Create a creamy mixture of Titanium White with a touch of Cadmium Orange. Take up whichever brush works best for the part of the bridge you're working on and carefully apply the highlight on the top of the bridge rail and on the right side of the other bridge supports. Avoid using a solid line when highlighting here; a broken line will work better.

17 Highlight the Foliage on the Left

The foliage on the left side of the painting is much less intense. The best color for this is a mixture of three parts Hooker's Green with one part Thalo Yellow-Green. You may have to add more or less of the Thalo Yellow-Green, depending on how bright the mixture is. The color mainly needs to be about three shades darker than the foliage on the right side of the waterfall. Load the end of your no. 10 bristle brush and dab on the highlights, just as you did on the right side. Leave interesting pockets of negative space showing through the highlights so the foliage will have depth and form.

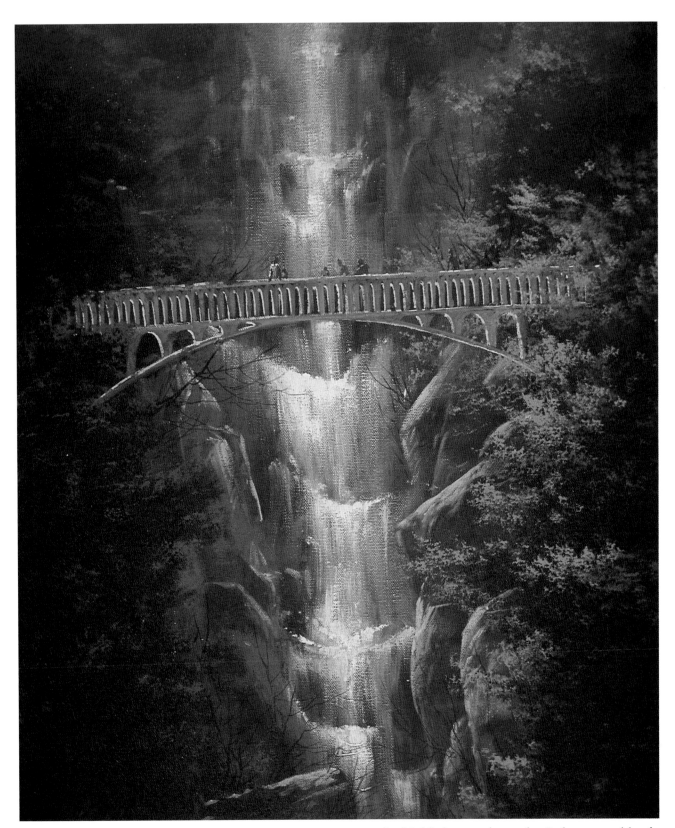

18 Add the Final Details

Search the painting for areas that should stand out more. For instance, at the top of each shelf of the waterfall, you may want to dab in some small, thick gobs of pure gesso to give the falls a little more sparkle. You also may want to intensify the foliage on the right side with pure Thalo Yellow-Green or some of the highlights on the rocks. I chose to add a few people wandering along the bridge as well as dead branches along the edge of the woods. How bright or how detailed you make it at this stage is more a matter of choice than right or wrong, use your artistic license and have fun!

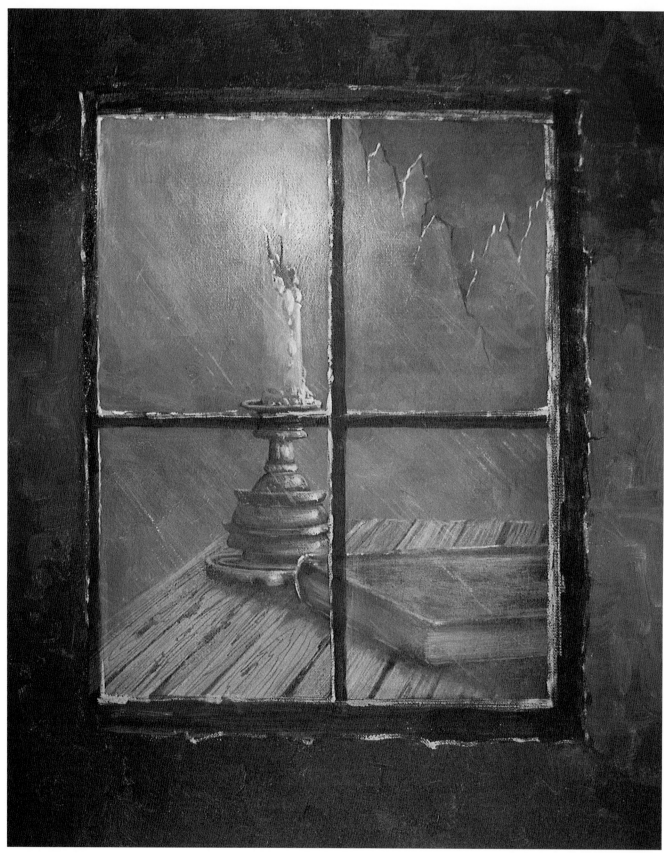

The Window's Glow
20" × 16" (51cm × 41cm)

The Window's Glow

In portraying different aspects of light—or any other painting technique, for that matter—it's often necessary to gather some props and put together your own arrangement. I've always been intrigued by glowing light from a window, campfire or candle. Having already painted two of those subjects, I put together a still life to study the effects of candlelight. Candlelight produces a glow similar to a campfire or an incandescent light bulb shining through a window, but the yellow-gold sphere of illumination around the flame is much smaller. You can see how the light affects some objects very differently than others. When I wanted an object to pick up this glow, I positioned it closer to the flame. The brass candleholder was an excellent addition; its reflective quality and rounded contours picked up the subtle glow, creating a more interesting design.

1 Basic Sketch
As usual, grab your soft vine charcoal. Make a rough sketch of the basic opening for the window and sketch in the basic location of the table. It isn't necessary to sketch in the candle, book or windowpanes.

2 Underpaint the Background Inside the Window
The background should be a medium-dark mottled gray. You'll do your mixing on the canvas instead of on the palette in this step. Apply dabs of gesso with your no. 10 bristle brush using broad impressionistic brushstrokes. While the gesso is still wet, begin adding Ultramarine Blue, Burnt Sienna, Dioxazine Purple and touches of Hooker's Green. Experiment with different amounts of these colors to end up with the mottled grayish background. Avoid overblending or the background will become dull and muddy.

3 Underpaint the Table

The table should be underpainted a brownish gray. To do this, double load your no. 6 bristle brush with equal amounts of Burnt Sienna and Ultramarine Blue. Scrub this mixture on the table. As you go, add touches of gesso to change the value. Notice that the gesso not only changes the value, but it also exposes the true color of the mixture. Consider the value: if it's too light, add a touch more Burnt Sienna and Ultramarine Blue; if it's too dark, add a little more gesso.

4 Create the Table's Wood Tone

For this step, you'll drybrush a lighter glaze on top of the table to create a soft wood tone. First, create a mixture of about three parts gesso and one part Burnt Sienna, then add a touch of Ultramarine Blue. Thin the mixture to a soft buttery consistency, then load a small amount across the end of your no. 10 brush and carefully skim it across the surface of the table with a light dry-brush stroke. If needed, repeat this step one or two more times to get the intensity that you want. Be sure you allow some of the background to show through.

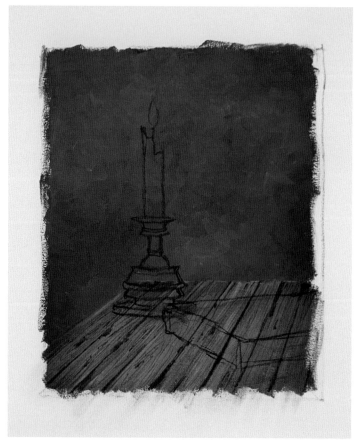

5 Detail the Table

Create a mixture of equal parts Burnt Sienna and Ultramarine Blue, thinning it to an inklike consistency. Load your no. 4 script liner brush by rolling it around in the mixture until it forms a point, then paint in the cracks, wood grain and holes in the wood. You may want to lightly sketch in the cracks with your soft vine charcoal to be sure you have the perspective of the boards correct. Have fun, but be careful not to over-detail it.

6 Sketch in the Candle and Book

As accurately as possible, sketch in the candleholder, candle and book with your soft vine charcoal. If your sketch doesn't show up well against the dark background, you may want to use a piece of white chalk or a light-colored pastel pencil. Conté pencils also work well; they come in a variety of colors and hold a point, but are soft like charcoal and wipe off easily.

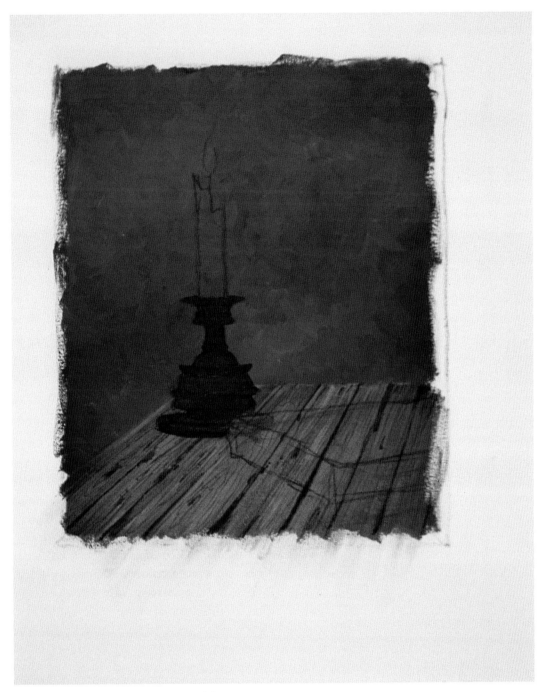

7 Underpaint the Candleholder

Make a creamy mixture of three parts Burnt Sienna and one part Burnt Umber. Take your no. 4 flat sable brush and block in the entire brass candleholder. For the areas that are too small for the no. 4 flat, you may want to use your no. 4 round sable. Be sure you have good, solid coverage with no canvas showing through.

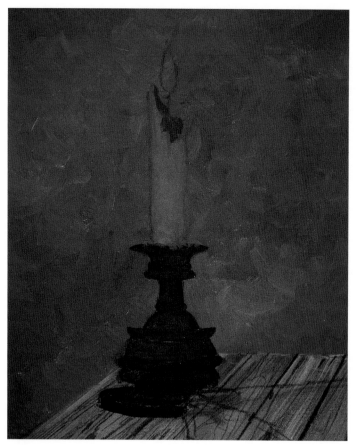

8 Underpaint the Candle

I've chosen to make this candle white, but you may choose any color you want. For a white candle, you want a warm-toned white. Underpaint it with a mixture of two parts Burnt Sienna, two parts gesso and about one part Ultramarine Blue. Block in the entire candle with your no. 4 flat sable.

9 Detail the Candleholder

This step may take some experimenting, so don't be afraid to paint over something to start again. To begin, create a rich yellowish gold mixture of two parts Burnt Sienna, two parts Cadmium Yellow Light and one part gesso. With either your no. 4 round sable or no. 4 flat sable, highlight the holder with short dry-brush strokes, carefully blending into the underpainting. The right side is a little brighter, so once you have the basic highlight in place, add a little more gesso to the mixture and dab this on the brighter areas. This helps create more roundness.

10 Detail the Candle

Create a very thin wash of gesso and water. If you want your candle to have a little more color, don't be afraid to tint the wash with a little Cadmium Red Light, Cadmium Orange or Cadmium Yellow Light. With your no. 4 flat sable, begin highlighting at the right side of the candle, carefully blending across to the dark side. The first application of this wash will give you the basic candle form. Go over this wash one, two or three more times until you achieve the brightness you want.

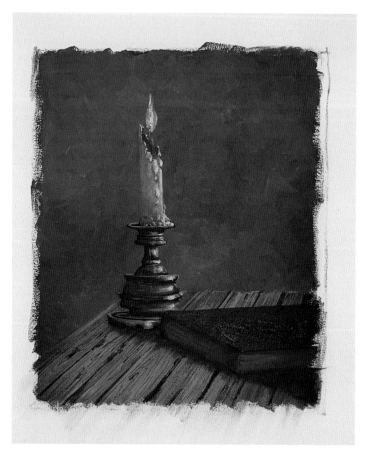

11 **Paint the Wick and Flame**
Paint the wick with a dark mixture of Burnt Sienna and Ultramarine Blue using your no. 4 script liner brush. When this is finished, create a mixture of equal parts Cadmium Yellow Light and Cadmium Orange. Use your no. 4 round sable to paint in the basic shape of the flame. Keep the edge of the flame fairly soft. Create a mixture of equal parts Cadmium Yellow Light and gesso. Dab this whitish yellow color in the center of the flame with your no. 4 round sable, allowing some of the orange underpainting to show through. Flames can be many different colors, so it's OK if your flame isn't exactly the color shown here.

12 **Underpaint the Book and Cast Shadow**
Mix pure Hooker's Green with a little bit of gesso to make a dark green. Block in the cover of the book using a no. 4 flat bristle brush. For the pages of the book, mix three parts Ultramarine Blue with one part Burnt Sienna and enough gesso to change the value to a medium gray. With your no. 4 flat sable brush, underpaint the pages. To create a shadow color, add a slight touch of Dioxazine Purple to the leftover mixture. With your no. 4 bristle brush, scrub in the cast shadows from the candle and the book. Keep the edges of the shadows fairly soft.

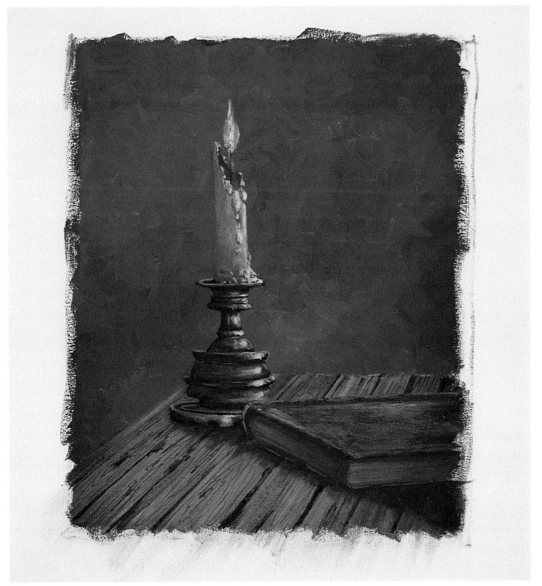

13 Highlight the Book

To highlight the cover of the book, create a mixture of three parts gesso and one part Hooker's Green. With your no. 4 bristle brush, drybrush this color on the cover of the book using a scumbling stroke. Be sure to allow some of the background to show through. To highlight the pages, create a light gray mixture of gesso with touches of Ultramarine Blue and Burnt Sienna. With your no. 4 bristle brush, drybrush this highlight along the edges of the pages. Remember—you don't want a lot of detail here, only a few light and dark contrasting values to create form.

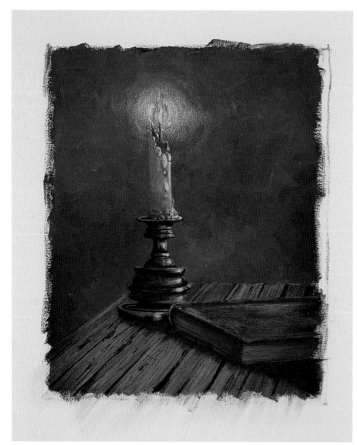

14 **Paint the Glow Around the Flame**
Create a mixture of two parts gesso, one part Cadmium Yellow Light and one part Cadmium Orange. Load your no. 4 bristle brush across the tip with a small amount of paint. Starting close to the flame, apply this color with a dry-brush scrubbing technique. Scrub in a circular motion around the flame. As you scrub, keep in mind that the color gradually fades out into the background around the flame. Avoid hard edges.

15 **Paint the Window Frame**
It might be a good idea to take your soft vine charcoal and sketch all of the components of the window in first. For the color, create a creamy mixture of equal parts Ultramarine Blue and Burnt Sienna. Paint in the framework around the window and the crosspieces for the windowpanes using your no. 4 bristle brush. Make the right side of the window wider than the left side to help create a little depth.

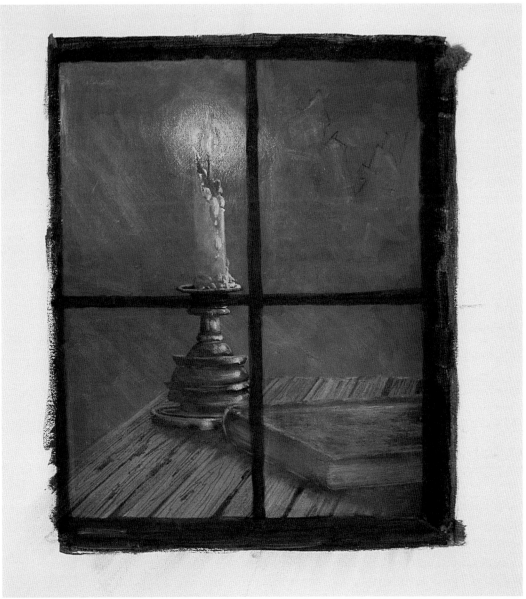

16 Paint the Window Panes

This step strictly involves a glazing technique. First, mix a little gesso into water to create a very thin, whitish glaze. Load the mixture evenly across the tip of your hake brush. With a careful, light, feather stroke, apply this glaze to all of the windowpanes. I can't stress enough how important it is to use a very light stroke. When you come to the broken upper-right pane, simply paint around the broken area. You'll highlight the edges of the broken glass later. If this first glaze does not satisfy you, don't hesitate to repeat this step one or two more times.

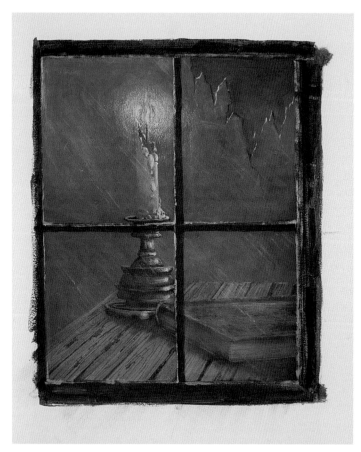

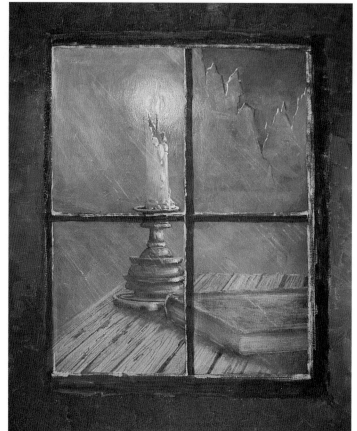

17 **Highlight the Window Panes and Broken Glass**

Create a creamy mixture of gesso with a touch of Cadmium Yellow Light. With your no. 4 script liner brush, paint a few angled streaks across the glass panes. Keep these very thin and try to consistently keep the streaks at the same angle. Add a little Cadmium Orange to the mixture, using it to highlight the edges of the broken panes. With this mixture and your no. 4 round sable, highlight the edges of the wooden crosspieces and the edge of the window frame.

18 **Mottle the Area Around the Window**

This step will vary depending on how dark or light you want this area, but making it darker helps the viewer focus on the glow of the candle. With your no. 10 bristle brush, mottle various darker colors such as Ultramarine Blue, Burnt Sienna, Hooker's Green and touches of Dioxazine Purple. Add touches of gesso to create minor value changes. Apply these colors using quick, loose strokes. It doesn't matter if the color ends up on the brownish side, greenish side or grayish side. Mainly, you need to cover the canvas well and include slight value changes.

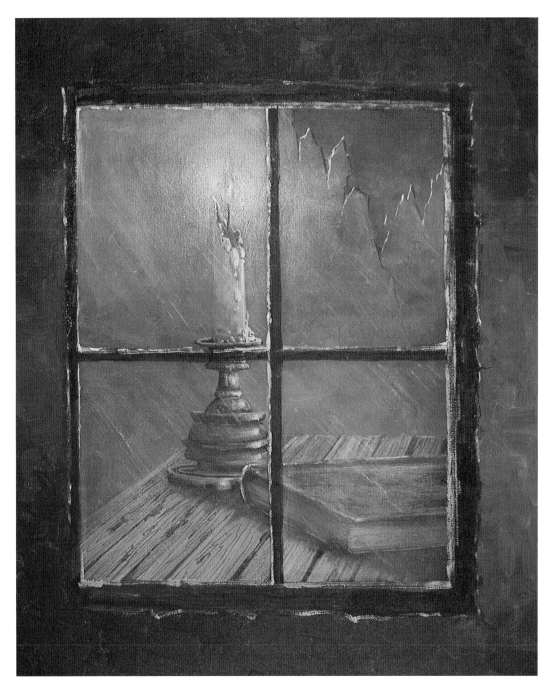

19 Add Miscellaneous Details and Highlights

This may not even be a step for many of you; if you're satisfied by now, then it would be best to quit. However, if you think you need some more intense highlighting or minor details, this is the time to do it. For instance, you can increase the intensity of the glow around the flame, add a few brighter spots to the candleholder or detail the wooden table a little bit more; it's really up to you. Have fun with your artistic license, but remember the three Ps: Don't Piffle, Play or Putter.

Canyon Cedars
16" × 20" (41cm × 51cm)

Canyon Cedars

In Canyon Cedars, *light plays an important role once again. However, the lighting situation here is fairly unusual because of where we are standing in relation to the sun. We're standing on a cliff overlooking the Grand Canyon, far above a normal horizon line. Though it's not sunset, the sun has started to go down, bringing it closer to the horizon and its rays deeper inside the canyon below the cliff. The width and depth of the canyon also affect the angle and quality of the light. As the sun shines up though the canyon, it illuminates the edges of all the rock layers, and backlights the large cedar tree on the edge of the cliff. The cedar tree, as with most backlit objects, becomes a silhouette. The foreground rocks have a more three-dimensional feel than the rock layers and cedar tree because they receive more evenly distributed light. You can see how light can create two or three different effects in the same painting.*

1 Basic Sketch

It isn't necessary to create a complicated sketch here. Just take your soft vine charcoal and make a rough sketch indicating the general contour of the mountain ranges.

2 Paint the Sky

This sky is very light and soft. To create it, take your hake brush and apply a light coat of water, followed by a liberal coat of gesso. While the gesso is still wet, add just a touch of Cadmium Red Light at the horizon and blend it up using crisscross feather strokes until it fades out. Next, paint a bit of Ultramarine Blue across the top of the sky. Blend it down until it fades out. When you finish, you should have a very soft, bluish white tint.

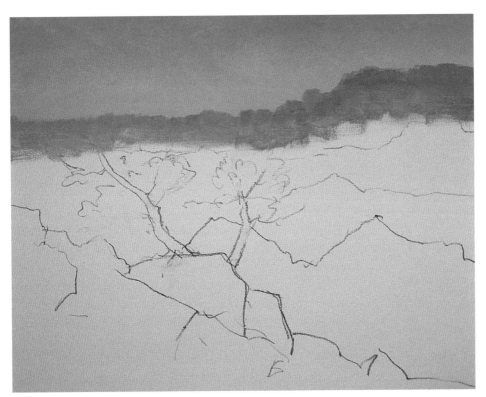

3 Paint the Background Mountains

These next four or five steps are identical in nature; the only real difference is that as each mountain range comes forward, the value gets darker. Since you'll be using the same mixture for these steps, just making slight value adjustments, go ahead and mix the basic color. The base will be gesso. To the gesso, add a touch of Ultramarine Blue, a touch of Burnt Sienna and a touch of Dioxazine Purple. Scrub in the first layer of mountains with your no. 10 bristle brush. Notice how soft they are and how they fade into the sky with no hard edges.

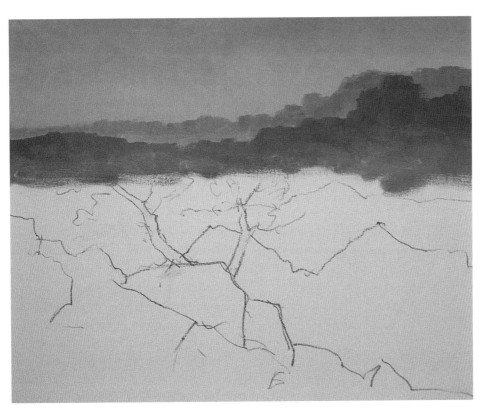

4 Paint the Next Layer of Mountains

For this layer, take some of the basic mixture from step 3 and darken the value slightly by adding more Ultramarine Blue, Burnt Sienna and a touch of Dioxazine Purple—maybe even a little Hooker's Green. With the same no. 10 bristle brush, scrub in this layer of mountains. Be sure you begin developing definite shapes and use loose, impressionistic brushstrokes. It is important that your brushstrokes are visible; this helps give the mountains their form as well as a certain ruggedness.

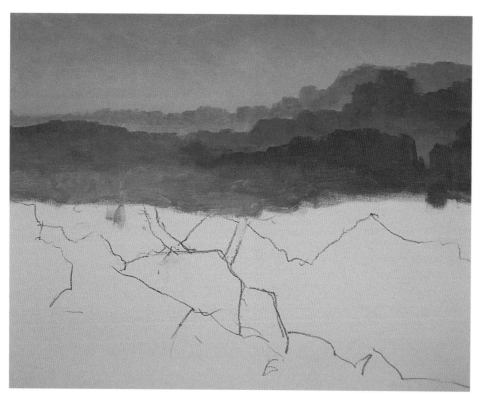

5 Paint the Third Layer of Mountains

Take the mixture from the previous step and darken the value by adding a little more Ultramarine Blue, Burnt Sienna and a touch more Dioxazine Purple. Remember, this mixture needs to be only slightly darker than the mixture in step 4. When you're satisfied with the value, paint in this layer of mountains with your no. 10 bristle brush. Starting with this layer, leave the mountains on the left side less structured as they fade into a whitish blue haze. To accomplish this, add more gesso and a touch of Ultramarine Blue directly to the canvas as you paint this layer of mountains, then scrub it to create a haze.

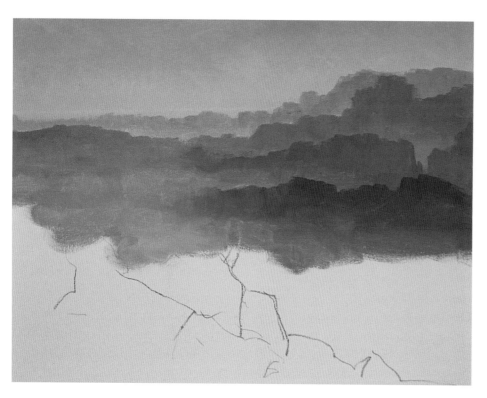

6 Paint the Fourth Layer of Mountains

No surprise here: take the darkened mixture you just used in step 5 and darken the value even more by adding a little more Ultramarine Blue, Burnt Sienna and Dioxazine Purple. If you're experimenting with a different color scheme, go ahead; just don't alter the value established in this step. As in the previous steps, paint in this layer of mountains with your no. 10 bristle brush. Gradually fade them across into the hazy area to the left. Add some gesso and a touch of Ultramarine Blue as you paint to create this gradual fade.

7 Paint the Fifth Layer of Mountains

These steps might sound like a broken record, but this is the final layer of mountains before the foreground. Take the mixture you just used in step 6, but now darken the value by two or three shades. I suggest you add Burnt Sienna, Ultramarine Blue and a little more Dioxazine Purple. You'll have to experiment with this value until you're satisfied. As far as color goes, it needs to stay on the cool side, so don't let it get too brown. Now, take your no. 10 bristle brush and paint this mountain range, gradually letting it fade across into the hazy area just as you did with the other mountain ranges.

8 Highlight the Mountain Ranges

Create a creamy mixture of gesso colored with a bit of Cadmium Orange. Take your no. 4 flat sable brush and load a small amount on the tip. You'll want to accent the outer raised areas of the first four ranges only slightly, so be very selective where and how much of a highlight you put on each range. As you can see, it doesn't take too much to create these three-dimensional forms. To highlight the closest mountain range, add a bit more Cadmium Orange and also a little Cadmium Yellow Light to the highlight mixture, then highlight the rugged outer edges of this range.

9 Highlight the Misty Areas

This area is really important because the whitish light sets the mood for the entire painting. It creates depth, becoming the background for silhouetted cedar trees. Start by creating a mixture of gesso with a very slight touch of Ultramarine Blue and a touch of Dioxazine Purple. This should be nothing more than white with a slight bluish tint. Load a small amount on your no. 6 bristle brush and scrub in this tint using a circular dry-brush motion. The lightest, brightest area should be directly behind the large cedar tree, so be sure you know where this tree is supposed to go.

10 Block in the Eye-Stoppers

Create a mixture of two parts Hooker's Green, one part Dioxazine Purple, one part Burnt Sienna and a dab of gesso. This should end up being a fairly deep forest green. Now, load the very tip of your no. 6 bristle brush and dab in the smaller trees on each side of the canvas. These trees act as eye-stoppers, which is important, but be careful not to make them too big or tall. Keep the edges of these trees fairly soft.

11 Underpaint the Foreground Rock Formations

This is a really fun and exciting step. You'll create a fairly dark underpainting by mixing the colors on the canvas, using lots of loose, broad brushstrokes. First, apply fairly thick layers of Burnt Sienna, Ultramarine Blue, Dioxazine Purple and touches of gesso with your no. 10 bristle brush. To create minor value changes, you can throw in touches of Hooker's Green and Cadmium Red Light. The important thing is to mottle these colors together using quick, bold brushstrokes. Avoid overblending or the colors will turn into one dark, muddy tone. It's important to see the brushstrokes as well as the subtle value and color changes; these will come in handy later when you highlight the foreground.

12 Sketch the Cedar Tree Trunk

Using your soft vine charcoal, make an accurate but basic sketch of the large cedar tree. Don't worry about sketching in all of the small limbs.

13 Underpaint the Cedar Tree

Mix equal parts of Burnt Sienna and Ultramarine Blue, making the mixture creamy. Paint in the main part of the tree with your your no. 4 round sable brush. Once the main structure is complete, thin the mixture to an inklike consistency and switch to your no. 4 script liner brush. Add any smaller limbs that are connected to the main structure, but don't paint too many. You'll add additional limbs after putting on the foliage.

14 Add Foliage to the Cedar Tree

Mix four parts Hooker's Green with two parts Dioxazine Purple and one part Burnt Sienna. Make the mixture nice and creamy. Next, load a small amount on the very end of your no. 6 bristle brush. Be careful not to overload the brush. To make sure you haven't overloaded it, make a few test dabs on a scrap piece of canvas. Now, dab in the needles, starting at the center and working your way out. As usual, make sure you have a nice arrangement of negative space in, around and through the needle clumps. In other words, don't make the same clump of needles over and over, all evenly spaced.

15 Highlight the Rock Formations

This step may give you some trouble, mostly because many of you will work too hard to make it look photographic. All you want to do here is create the suggestion of rocks by using quick, impressionistic strokes. First, create a base mixture of about four parts gesso with about one and a half parts Cadmium Orange and one and a half parts Ultramarine Blue, thinning it to a creamy consistency. Load a small amount on your no. 4 bristle brush. This first highlight is only to establish the basic shape of the rock formations, so if it appears too bright as you apply it, thin it a little more, put less on your brush, or add a touch more Ultramarine Blue to the mixture. Scrub on this highlight throughout the rocks, leaving interesting pockets of negative space, which in turn serve as shadows.

16 Add Final Highlights to the Rock Formations

Take the highlight mixture from the previous step and intensify the value by adding more gesso and a touch more Cadmium Orange. With your no. 4 flat sable brush, rehighlight some of the more prominent areas of the rock formations. For color variation and harmony, add some Cadmium Red Light to the mixture to create a pinkish highlight, then highlight a few rocks with this color. If needed, you can repeat this entire step one or two more times to achieve various highlight intensities.

17 Underpaint the Twisted Foreground Log

Sketch in the basic form of the log with your soft vine charcoal. Next, create a mixture of two parts Burnt Sienna, two parts Ultramarine Blue and one part Dioxazine Purple. You need this dark, solid color because the log is right up in the foreground and shadowed. Use any of the smaller brushes that work best for you to underpaint the log.

18 Highlight the Twisted Log

Mix a little Cadmium Orange and Ultramarine Blue into gesso to create a medium grayish tone. With your no. 4 flat sable brush, drybrush on this highlight to suggest weathered, twisted wood. The twisted effect is fairly challenging, so if you're not satisfied with your results, don't hesitate to block it out with the underpainting color and begin again. Just remember that you need to use a dry-brush stroke with a light touch here.

19 Add the Final Details and Highlights

Now is the time to look through the painting for areas that need more highlights—maybe on a few of the rocks. Also, add a few more tree limbs on the large cedar tree and in the foreground. Of course, you can use your artistic license here. Have fun finishing the painting in a way that pleases you. Just don't piffle, play or putter.

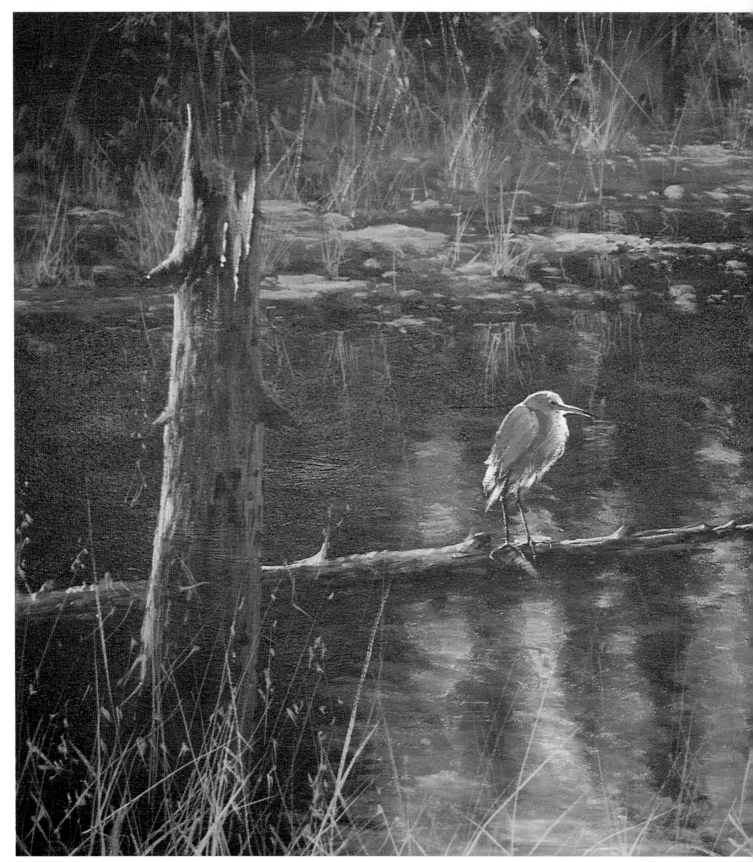

The Egret
16" × 20" (14cm × 51cm)

The Egret

In The Egret, *light creates deep shadows and intense highlights. The intensity of the light and the depth of the shadows are a dead giveaway that the setting is either early morning or late evening. During a trip to central Florida to give a lecture and workshop, one of my students and I decided to take advantage of the early morning Florida sun. We started our adventure hoping to find some unique lighting situations. Sure enough, we stumbled across this beautiful little backwater scene with this brilliantly lit egret. At first, we were drawn to the magnificent light, but it wasn't long before we began to notice its other effects on the different elements of the scene. For instance, the strong contrast of light and dark really established the great reflective quality of the water. We also noticed the incredible play of light on the weeds, bushes, twigs and finally, the dead tree stump. What a great study in light!*

1 Basic Sketch
Roughly but accurately sketch the main objects using your soft vine charcoal. No details are necessary, just the basic outlines.

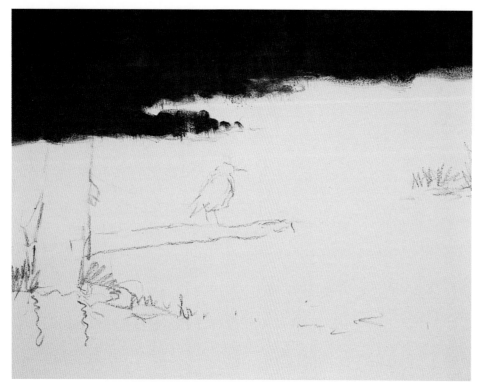

2 Underpaint the Background
Using your no. 10 bristle brush, create a mottled background by mixing several darker colors directly on the canvas. Begin by applying Hooker's Green, Burnt Sienna, Dioxazine Purple, touches of Cadmium Orange and touches of Thalo Yellow-Green. Add small amounts of gesso to create subtle value changes. Use quick, bold impressionistic strokes, but avoid overblending or it will turn into one solid tone. You want to be able to see brushstrokes and hints of each of the colors you used. To get nice, opaque coverage, it's important to apply these colors heavily.

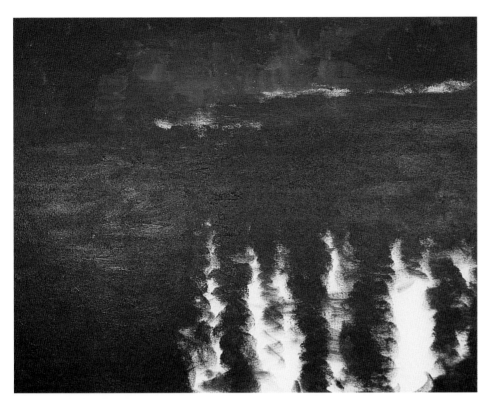

3 Underpaint the Dark Areas in the Water

This step is very similar to step 2, but you'll want to use shorter, choppier, horizontal brushstrokes. With your no. 10 bristle brush, paint a combination of the following colors in the darker areas of the water: Hooker's Green, a touch of Burnt Sienna, a touch of Dioxazine Purple and a very small amount of gesso. Apply these colors directly to the canvas with a fairly heavy hand. Leave open pockets of space where the water will reflect the sky.

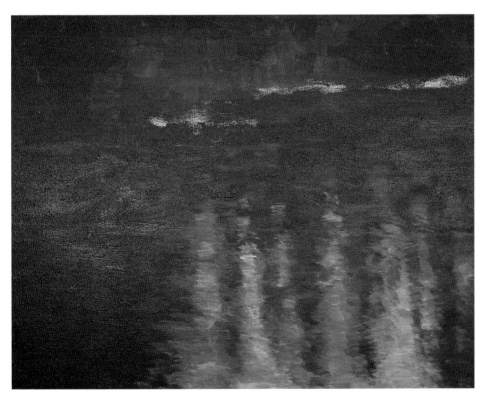

4 Add a Light Blue Reflection

Create a light blue mixture of three parts gesso and one part Ultramarine Blue. With your no. 6 bristle brush, apply this light blue color in the open areas. You should use short, choppy, horizontal brushstrokes with a slight wavy motion. This waviness makes the water and reflections appear to have a slight ripple to them. It is important that you get opaque coverage, so apply the paint fairly heavily.

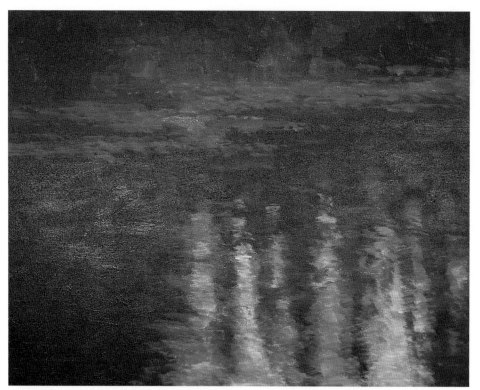

5 Underpaint the Shoreline

Mix Burnt Sienna with a touch of gesso and a touch of Ultramarine Blue. This should be a fairly dark brownish gray, but it should still be slightly lighter than the dark greenish underpainting. Scrub this color along the area of the shoreline with your no. 6 bristle brush using choppy, horizontal strokes. The irregular shape of the shoreline and the slight indentations along the edge add character, so don't make a straight line across the shoreline area.

6 Add Background Brush

Create a mixture of two parts Hooker's Green, one part Burnt Sienna, one part Thalo Yellow-Green and then a slight touch of gesso. Using your no. 10 bristle brush, scumble, scrub and drybrush in the suggestion of grasses and brush. In reality, these should only be minor suggestions, subtle contrasting areas to give the background a little depth—so don't overdo it.

7 Highlight the Background Brush

Mix Thalo Yellow-Green with a touch of gesso and a touch of Cadmium Orange. Using your no. 4 bristle brush, dab in some brighter, more detailed suggestions of bushes and clumps of grass. You'll probably have to experiment a little with the background bushes. As always, be sure you have interesting pockets of negative space around these bushes. Next, thin the mixture to an inklike consistency and paint in a few taller grasses with your no. 4 script liner. Since you'll add the final tall grasses in the last step, just add a few at this point.

8 Highlight the Shoreline

Create a creamy mixture of four parts gesso with about one part Cadmium Orange, then add a touch of Ultramarine Blue to slightly gray it. This color will still create a fairly bright, warm highlight. Scrub some brighter highlights throughout the shoreline area with your no. 4 bristle brush. Leave some of the background showing through in places to add a little three-dimensional form to the shoreline. Now, switch to your no. 4 flat sable brush and dab in a few highlights here and there to suggest small pebbles, rocks or rough ground. Don't be afraid to work your way out into the water area with these highlights.

9 Add the Plant Reflections

Thin some Thalo Yellow-Green to a creamy consistency. Load a small amount on your no. 4 round sable, then carefully paint in the reflections of some of the plants that you see above the shoreline. Use a slightly wobbly stroke to suggest rippled water. You don't need a reflection for every single blade of grass; just put in enough to give the water a little character.

10 Sketch the Stump and Fallen Log

Since the background is dark, you may need light-colored chalk to sketch in the stump and fallen log. Your biggest concern is the location, size and proportion of the stump and log in the water, so make sure you're satisfied with those details before moving on.

11 Underpaint the Stump and Fallen Log

For this step, double load your no. 4 bristle with equal amounts of Ultramarine Blue and Burnt Sienna. To deepen the value, you can add touches of Dioxazine Purple. Now, paint the stump using short, choppy, vertical strokes. Using the same colors, paint the fallen log the same way. Smudge the bottom edge of the log into the water so there won't be a hard line.

12 Highlight the Stump and Fallen Log

To create highlights on the stump and log, you'll need to create a mixture of about four parts gesso and one part Cadmium Orange, graying it with a touch of Ultramarine Blue. Using your no. 4 flat sable, make very short, choppy strokes on the left edge of the stump with this highlight color. For a more barklike texture, leave areas of the underpainting showing through. Gradually fade these choppy strokes, letting them lighten towards the center of the stump until they disappear into the dark area. Use this same technique for the fallen log.

13 Add a Reflected Highlight to the Stump

The water reflects violet-blue light against the stump. To create this, first mix four parts gesso with about one part Ultramarine Blue and a little touch of Dioxazine Purple. The result should be a medium-value bluish violet. With your no. 4 flat sable brush, drybrush this highlight on the right side of the stump, gradually fading it as you reach the center of the stump. This color will appear very intense closeup, but if you step back about six feet (1.8m)—which is the average viewing distance for a painting— this intense bluish reflected highlight fades out dramatically and gives the stump a softer, more rounded quality on the shadowed side. It's important to put the highlight on more intensely than you think you should; distance will take care of the rest.

14 Sketch the Egret

If the background is too dark for your vine charcoal, use a light-colored piece of chalk. It's important to have an accurate sketch of the egret, so take your time and make sure you've sketched it just right.

15 Underpaint the Egret

Mix three parts gesso with about one part Ultramarine Blue, then add touches of Burnt Sienna and Dioxazine Purple. It's very easy to add too much Dioxazine Purple, so be careful. The result should be a medium-value bluish gray. Now, use either your no. 4 flat or round sable to block in the egret, keeping the egret's edges fairly soft. Darken the mixture slightly with a little more Ultramarine Blue and Burnt Sienna. Drybrush this darker color around the wing to separate it from the main body. For the eye, create a very dark mixture of equal parts Ultramarine Blue and Burnt Sienna, then dab a small dot where the eye is. Use this color for the legs and feet of the egret, using a no. 4 round sable to paint them.

16 Highlight the Egret

Mix gesso with a slight touch of Cadmium Orange to get the highlight color. Since you're just tinting the gesso, don't overdo the Cadmium Orange. With your no. 4 round sable, carefully drybrush the highlight color around the outer edge of the bird. Use a very light featherstroke (no pun intended) so the edges of the bird will be soft. You may have to repeat the highlighting process one or two more times to get the right intensity.

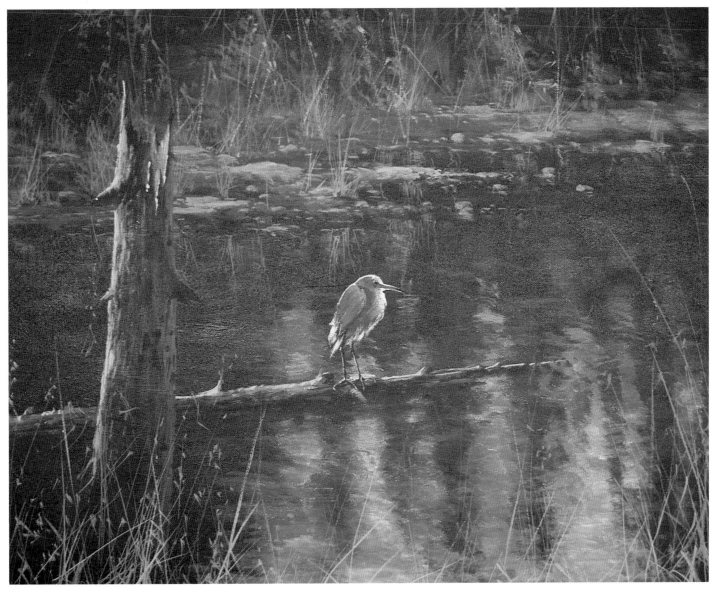

17 Add the Final Details and Highlights

OK, it's time to pull out your artistic license and finish this up! Create a base mixture of about three parts Thalo Yellow-Green with one part gesso. Thin this mixture to an inklike consistency and then paint the taller grasses in the background with your no. 4 script liner. Follow up with some taller grasses in the foreground. Now you can add some other colors to the original mixture, such as a touch of Cadmium Orange, Cadmium Yellow Light or more gesso, and then paint in some additional grasses using these different values and colors. Another area that needs a little more highlighting is the bluish area of the water, so take some gesso and tint it with Ultramarine Blue. Drybrush in a few brighter highlights in the bluish area with your no. 4 flat sable. Once you've finished painting these highlights, search the painting for areas to adjust. Would any additional highlights or grasses give the painting a little more life? Avoid overdoing the details!

Index

The best in fine art instruction and inspiration is from North Light Books!

These books and other fine art titles from North Light Books are available at your local art & craft retailer, bookstore, online supplier or by calling 1-800-448-0915.

Bring new life to your paintings with this lively and liberating guide! With short sessions of sixty minutes or less, you'll focus your efforts on the essence of your subject, enabling you to master the medium rather than the tiny details that slow you down. Step-by-step demonstrations, examples and exercises make getting started easy. An hour is all you need!

ISBN 1-58180-196-3, hardcover, 144 pages, #31969-K

Learn how to properly execute basic acrylic painting techniques-stippling, blending, glazing, masking or wet-in-wet-and get great results every time. Jacqueline Penney provides five complete, step-by-step demonstrations that show you how, including a flower-covered mountainside, sand dunes and sailboats, a forest of spruce trees and ferns, a tranquil island hideaway and a mist-shrouded ocean.

ISBN 1-58180-042-8, hardcover, 128 pages, #31896-K

This book is for every painter who has ever wasted hours searching through books and magazines for good reference photos only to find them out of focus, poorly lit or lacking important details. Artist Gary Greene has compiled over 500 gorgeous reference photos of landscapes, all taken with the special needs of the artist in mind. Six demonstrations by a variety of artists show you how to use these reference photos to create gorgeous landscape paintings!

ISBN 1-58180-453-9, paperback, 144 pages, #32705-K

Betty Carr shares her time-tested secrets for capturing the awe-inspiring qualities of light on canvas. You'll learn how to use light to create depth, form, mood and atmosphere through 12 complete step-by-step demonstrations, close-up painting details and keys for "seeing" light and true color. Artists of all skill levels will come away with the ability to harness the power of light!

ISBN 1-58180-342-7, hardcover, 144 pages, #32312-K

Mastering basic brushwork is easy with Mark Christopher Weber's step-by-step instructions and big, detailed artwork. See each brushstroke up close, just as it appears on the canvas! You'll learn how to mix and load paint, shape your brush and apply a variety of intriguing strokes in seven easy-to-follow demonstrations.

ISBN 1-58180-168-8, hardcover, 144 pages, #31918-K